Basic
Black and White
Photography

Basic Black and White Photography

Karl M. Rehm

AMPHOTO

American Photographic Book Publishing Co., Inc.
Garden City, N.Y. 11530

CONTENTS

PART TWO

PART THREE

PHASE 12

PART FOUR

The Print ## PHASE 13

PHASE 14

PHASE 15

INDEX

The production of a perfect picture by means of photography is an art; the production of a technically perfect negative is a science.

Journal of the Society of Chemical Industry—1890

PREFACE

Welcome to the art and technique of black-and-white photography. In the past few years, there has been a sharpened increase in photography, particularly at the secondary and college levels. With the growth of offerings in photography and related courses, there is now a corresponding interest in publications relating to photography. Despite this multiplicity of books, there still exists a need for a comprehensive basic text on photography for the beginner, which teaches rather than just tells.

It is the intent of this handbook to offer the basic techniques necessary to understand and operate the equipment to expose black-and-white film, process it, and produce high-quality black-and-white enlargements that reveal the thoughts that went into their making. The handbook is divided into six parts, each part being subdivided into related phases. Each phase is a lesson in itself, containing clearly defined objectives. Emphasis is placed on learning the basics of photography through the building of simple cameras. Each phase is illustrated with comparative photographs with a succinct text correlated with those photographs. The reader will be introduced to virtually all phases of basic black-and-white photography. Should he desire more information, reference to related works is given at the end of each phase.

The handbook is specifically written by a teacher of photography for use in beginning photography courses. While it may be adapted in many ways to a photo course, its division into eighteen phases allows easy integration into semester courses. This does not limit its usefulness to the person interested in learning more about photography or the individual about to take this on as an exciting hobby. Whoever you are, and for whatever purpose, may you have happy and creative experiences!

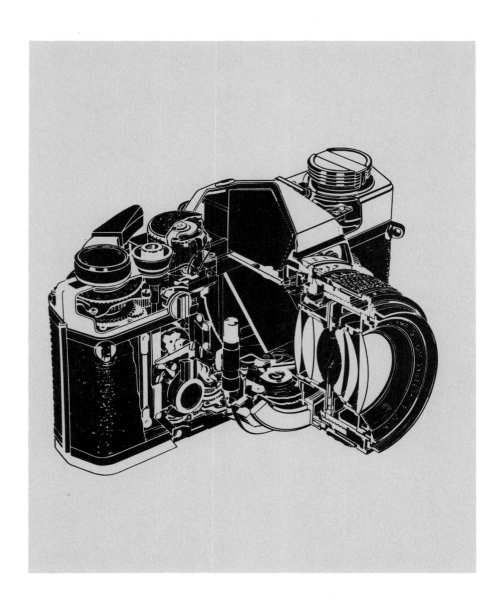

CAMERAS

PART ONE

THE SIMPLE CAMERA

While it is difficult to find a truly simple camera on the market today, only a lighttight box with a small opening, or aperture, is necessary for the exposure of film. Any other additions are refinements which add to the versatility and convenience of the camera's operation and to the quality of the negative and final photograph.

In the simple camera, the aperture could be a minute hole with no glass or lens. The light will travel through this pinhole and form an image at the back of the camera. The image is inverted as the drawing below shows. This is similar to the occurrence in the human eye in which the lens forms an inverted image on the sensitive retina.

This phenomenon of the inverted image was probably first noticed and used by the Arabs in the eleventh century. The dark room, or camera obscura, used by the Arabs, was later described by Leonardo da Vinci as being a dark room with a hole in one wall through which light cast an inverted image of the world outside onto the opposite wall. The image was traced onto the wall and became the basis for a sketch or painting. The principle of the simple camera has been known for a long time.

In camera obscura as well as in the simple camera, the aperture had to be kept small. Blurring was kept to a minimum only if a few rays of light were admitted. If the aperture was too large and many rays of light were reflected from the same point, the image became blurred. Today, the tiny circles that make up the image are known as circles of confusion. If they are too large, they tend to run together and blur the picture. In some instances in photography, they are a definite advantage, as we shall see later.

The simple camera produces an inverted image.

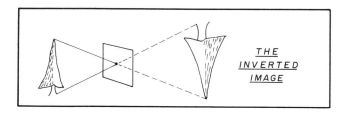

THE INVERTED IMAGE

APERTURE AND FOCAL LENGTH

In the simple camera, the size of the aperture not only influences the sharpness of the image, but it also regulates the amount of light entering the camera. As we increase the size of the opening, we increase the amount of light entering the camera.

The other factor that will influence the amount of light projected on the film in the camera is the distance from the aperture to the film itself. This distance is known as the focal length of the camera.

We can now compare these two factors which control light. By comparing aperture size and focal length, we can determine the relative aperture of the camera lens. The relative aperture is obtained by dividing the maximum aperture diameter into the focal length. If the aperture is 1 in. in diameter and the focal length is 6 in., then the relative aperture is 6 (written $f/6$).

LENS SPEED

The relative aperture is an indication of the speed of a lens. The nearer the focal length and the aperture are to a ratio of 1 to 1, the faster the lens. In our example, the relative aperture of 6 is quite slow. The speed of a lens is an indication of the amount of time needed to make an exposure. The faster the lens, the less time needed.

The comparison of aperture and focal length must always be made in the same numerical system. We cannot divide inches into millimeters and expect to get a reasonable answer. This is important because American-made lenses are often listed in inches while foreign-made lenses have focal lengths indicated in millimeters. The focal lengths of the two lenses below are in millimeters. One inch equals approximately 25 millimeters (written 25mm).

On this lens the 1:1.4 indicates the relative aperture, or speed, and the 50mm indicates the focal length. It is considered a fast lens as the ratio is almost 1:1.

This is a slower lens as the ratio of 1:3.5 is greater than the 1:1.4 lens. Notice also that the focal length is shorter.

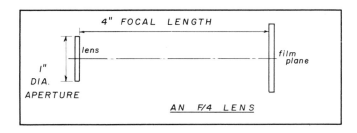

Maximum Aperture $\dfrac{\text{Relative Aperture}}{\text{Focal Length}}$

IMAGE SIZE

You have probably already said to yourself that it would be easy to build a very fast lens by merely shortening the focal length. The light would not have to travel such a long distance to reach the film. Basically, you are correct. The following table shows the relative aperture and focal length of a variety of lenses.

Relative aperture	Focal length
f/2.5	28mm
f/3.5	35mm
f/1.4	55mm
f/3.5	135mm
f/5.6	300mm
f/6.3	500mm

A short focal length gives a small image, while a long focal length gives a much larger image. The photograph below was taken with a 20mm lens, the one on the right with a 135mm lens.

It can be seen that generally the speed is greater with the shorter focal lengths. The question becomes why not use the shorter focal length exclusively. Compare the two accompanying photographs; each was taken with a different focal-length lens.

The focal length becomes an important factor to the photographer in that it can be used to determine the size of the image on the film plane. A short focal-length lens will cover a wide area and image size will be small. The area covered will decrease with a longer focal length, but image size will be larger. Thus, shortening the focal length to increase speed is not the only factor to be considered in lens construction.

We have learned that a simple camera is really not so simple. Even though it contains only two basic parts, the aperture and the lighttight box, it also contains two quantities that have an important relationship. This relationship of aperture size and focal length will have added meaning to you as you build the "kitchen camera" in the next phase.

OBJECTIVES — PHASE ONE

1. To know the basic parts of a simple camera.

2. To know the relationship of aperture and focal length as an indication of the speed of a lens.

3. To be able to calculate the relative aperture of a lens when given the focal length and the aperture diameter. Determine the speed of the following lenses:

Maximum aperture size in mm	Focal length	Speed or relative aperture
11	28mm	f/?
10	35mm	f/?
39	55mm	f/?
38	135mm	f/?
53	300mm	f/?
79	500mm	f/?

If you read carefully, you know that the answers are listed in the lens chart on page 17.

4. To know that image size increases with longer focal lengths.

FOR FURTHER REFERENCE

See *The Complete Photographer* by Andreas Feininger (Amphoto) for a complete discussion on focal length and lens speed.

THE THREE-CENT KITCHEN CAMERA

One of the easiest ways to put to use your knowledge of aperture, focal length, and image size is to actually build a camera. The "kitchen camera" is easy and inexpensive to build. It should be understood from the outset that the cost of this camera is three cents only if you get the oatmeal box from the kitchen free. Really, the only cost of the three-cent kitchen camera is for the material to make the aperture.

The aperture is made from a square inch of .001-in. thick brass shim stock, which is available from auto supply stores. The most difficult problem in making the kitchen camera is the formation of the aperture in the center of the brass shim

The three-cent kitchen camera is easy to build. An oatmeal box provides a convenient lighttight box. The only purchase necessary is the brass shim stock in which the aperture is drilled.

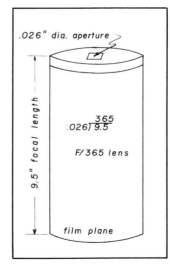

.026" dia. aperture

9.5" focal length

$\frac{365}{.026\overline{)9.5}}$

F/365 lens

film plane

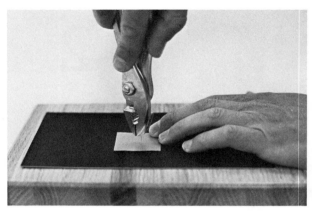
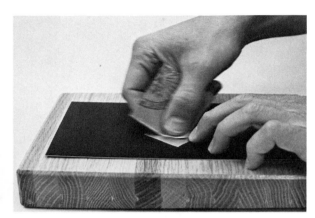
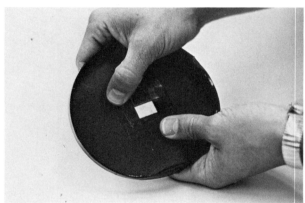
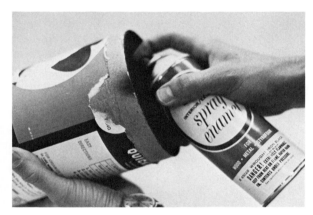

Building the three-cent kitchen camera. Top left: drilling the aperture with a needle. Top right: sanding the shim stock to remove sharp edges. Bottom left: attaching the aperture to the lid of the camera body. Bottom right: painting the camera interior to reduce reflections.

stock. As indicated in Phase One, the aperture opening must not be too large or the circles of confusion become too large and blur the image. Try using a Number 7 needle to make the aperture opening. This size gives a maximum aperture of .026 in. Dividing this into the focal length of approximately 9.5 in., providing you used the large economy-size box, gives a relative aperture of $f/365$. This is a bit slow when compared to present-day lenses, but workable.

As the needle is pressed into the shim stock, it should be rotated. This is easier to do if the needle is held with pliers. When the point of the needle comes through the stock, the back of the stock should be sanded with a very fine sandpaper and the needle started through from the opposite side. By working alternately from front to back, the needle can eventually be worked through with a smooth hole resulting. Do not enlarge the hole beyond the size of the shank of the needle. Now cut a ½-in. diameter hole in the center of the lid and cover the hole with the shim stock, attaching it with black tape. Paint the inside of the box with black poster paint or flat black spray enamel to cut down on any possible reflections. The camera is now ready to use.

EXPOSURE WITH THE KITCHEN CAMERA

Enlarging paper is easier to use in the kitchen camera than film because it is not as sensitive and because it can be handled more easily for our purposes. The aperture of the camera is not adjustable, so the amount of light entering the camera is constant. The question becomes a matter of the length of time that we should hold our finger, the shutter, away from the aperture after aiming the camera.

The sensitivity of a photographic material can be stated in terms of its ASA. ASA is the abbreviation for American Standards Association, which has standardized, along with nuts and bolts and various other items, the sensitivity of film and some photographic papers. Enlarging paper is slow when compared to film. It has an ASA of about 4. This will vary with different papers but not to a degree that will matter.

With our subject frontlighted by the sun, the exposure time will be the reciprocal of the ASA at f/16. This means that we would expose film or paper with an ASA of 4 for 1/4 sec. at f/16. Film with an ASA of 125 would be exposed for 1/125 sec. at f/16. You can see why we do not use film; it is a bit hard to judge 1/125 sec. We do have one problem, though, we do not have an f/16 aperture. However, we can produce a scale to arrive at the proper time for our aperture of f/365. We will begin our scale at f/1, which was indicated before as being a very fast lens. Using the f/numbering system, the next smaller opening is f/1.4. This size admits half as much light as f/1. The scale can be continued to arrive at a point very near the speed of our lens—f/365.

STANDARD f/NUMBERING SYSTEM

f/1	f/1.4	f/2	f/2.8	f/4	f/5.6	f/8	f/11	f/16	f/22
f/32	f/45	f/64	f/90	f/128	f/180	f/256	f/360		

If an aperture of f/1.4 admits one half the light of f/1, then the aperture setting of f/22 is going to admit one half the light of f/16. As our exposure was f/16 for 1/4 sec., and now we have decreased the amount of light by moving to f/22, we must correspondingly increase the time by doubling the time to 1/2 sec. Now we can put aperture and time together in a useable scale. In each step, we double the time as we move to the next smaller aperture.

Aperture	f/16	f/22	f/32	f/45	f/64	f/90	f/128
Time (sec.)	1/4	1/2	1	2	4	8	16

Aperture	f/180	f/256	f/360	f/512	f/1024
Time (sec.)	32	64	128	256	512

A logical starting point for our exposure is 128 seconds at f/365.

Now cut a piece of enlarging paper to fit the size of the bottom of the camera. Place the paper in the camera with the emulsion facing the aperture. The emulsion side is the shiny side, or if you have a matte-finish paper, the concave side. Naturally, as the paper is sensitive to light, this must be done in a dark closet or under safelight conditions in a photographic darkroom. Replace the lid containing

23

the aperture, place your finger or a piece of black tape over the aperture, take the camera outside, and make the exposure for the required time. Be sure the camera does not move during the exposure.

Since the exposure time is so long, you might want to take a photograph of yourself. Move quickly in front of the camera after removing the tape from the aperture. Move as little as possible once you have positioned yourself in front of the camera. Cover the aperture after the proper time has elapsed and take the camera back to the darkroom for the processing of the enlarging paper.

PROCESSING THE KITCHEN CAMERA NEGATIVE

Under safelight conditions, remove the paper from the camera. Phase Fourteen will cover the complete paper-processing sequence in detail. However, as you need to see your results, a brief summary will suffice at this point. See the following pictures and caption.

Step 1: Develop the paper negative in a paper developer mixed according to the package directions. Kodak Dektol is a good all-purpose paper developer. The picture should develop in one to two minutes. Step 2: Rinse the negative in a tray of water. Step 3: Fix the negative in a paper fixer for five minutes. Step 4: Wash the negative one hour in running water.

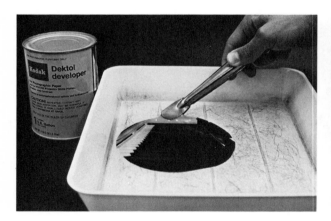
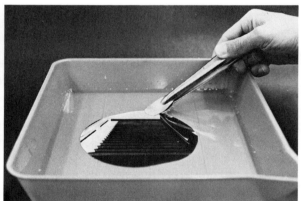
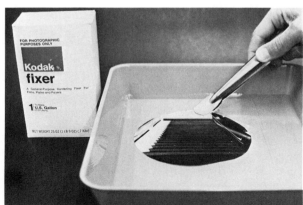
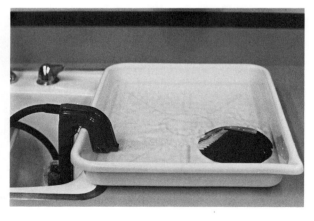

Far left: The paper negative should have both blacks and whites and tones between. Left: The positive contact print is made from the paper negative. All tones are reversed.

Should you find the negative is very dark after completing the negative processing steps, try a second exposure, reducing the time by 30 seconds. If the negative is very light, increase the exposure by 30 seconds. A properly exposed negative will have both white and black areas with many gray tones in between.

CONTACT PRINTING FROM NEGATIVE TO POSITIVE

There are several differences between your results from the kitchen camera and the photographs you normally see. First, the image is reversed—what is normally on the left is on the right. The image was also upside down, at least in the camera. Next, areas that were white in the scene are dark and areas that were dark are light. These are the normal characteristics of a negative. The reversed image has already been explained as a property of light entering a tiny opening. The white areas of the scene that are dark on the paper are a result of more light being reflected from those light areas onto the paper, and since the paper is sensitive to light, those areas are darker.

We are now ready to correct the above differences by printing a positive from the original negative. See the photos and captions that follow.

Separate the negative from the positive. Process the positive the same as the negative (see page 24). After the wash, the positive should be dried. You now have a positive print.

Step 1: Under safelight conditions, immerse a piece of enlarging paper the same size as the negative in a tray of water for two minutes. Step 2: Place the original negative you have just processed face down on the wet emulsion side of the unexposed paper (emulsion to emulsion).

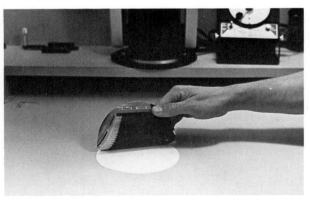

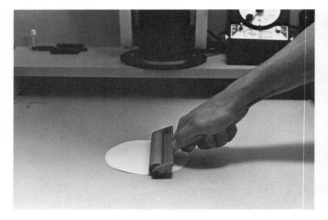

Step 3: With the negative on top, put the two papers on a flat surface and with a roller squeeze out all water so that the two pieces have close contact. Step 4: Cover all other sensitive papers and turn on the room light (white light) for one second, or place the two pieces of paper under the enlarger and expose for ten seconds at f/5.6.

You may notice that your photograph has a limited angle of view. That is, the photograph does not picture as much of the scene as you saw when taking the photograph. This can be explained by noting the relationship between focal length and the diagonal of the negative area. In the case of our camera, the diagonal of the negative is about 5 in., while the focal length is much more than that—about 9 in. As can be seen in the diagram below, a camera with such a relationship has a limited angle of view. Loosely we call this a long, or telephoto lens.

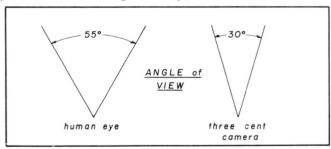

A normal lens will have a focal length equal to the diagonal measurement of the negative. A wide-angle lens will have a focal length less than the diagonal measurement of the negative. As indicated earlier, focal length influences image size. It also determines angle of view and is related to negative size.

OBJECTIVES—PHASE TWO

1. To construct a simple long-lens camera.
2. To calculate exposure based on a specific ASA using the *f*/16 rule.
3. To learn how to process enlarging paper.
4. To learn how to make contact positives from paper negatives.

FOR FURTHER REFERENCE

See *The Hole Thing: A Manual of Pinhole Fotography* by Jim Shull (Morgan and Morgan) for more on pinhole cameras.

CAMERAS WITH OTHER FOCAL LENGTHS

It was indicated in previous phases that shortening the focal length would reduce image size and increase angle of view. Examination of the photographs made with the short focal-length cameras constructed in this phase will show this change.

NORMAL FOCAL LENGTH

In building these cameras, it is not necessary to use exactly the same size boxes as those shown here. It is, however, necessary to remember that the normal focal length measures about the same as the diagonal of the negative. In the camera below, the focal length is 4 in. and the measurement of the film diagonal is also approximately 4 in., thus making it a camera with a normal focal length.

To reduce the amount of light, as less light is needed with the shorter focal length, and to avoid circles of confusion which will blur the picture, it is necessary to use a smaller aperture than used in the long-lens camera constructed in Phase Two. A Number 10 needle with a diameter of .018 in. was used on all of the cameras in Phase Three. With this you must calculate the relative aperture of each camera. Exposure time can then be determined from the scale on page 23.

A normal focal-length camera of 4 in., or 100mm, with a speed of f/222.

27

Two possible wide-angle cameras

SPECIFICATIONS

Kodak Film Can Camera
f/90 (No. 10 needle)
40mm focal length (1 ⅝ in.)
Normal exposure in bright sun: 8 seconds

A more costly camera due to the refined tripod mount.

Total cost: 8 cents

SPECIFICATIONS

Wax Paper Tube
Extreme Wide-Angle Camera
f/83 (No. 10 needle)
38mm focal length (1½ in.)
Normal exposure in bright sun: 6-8 seconds

Total cost: 8 cents

Note: The top slips off to load the film. Care must be taken in loading to make certain the film does not cover the aperture.

THREE FOCAL LENGTHS COMPARED

The three photographs on the next page were all taken from the same position with each of the three different focal-length cameras constructed in Phase Two and Phase Three. Note that the wide-angle camera covers a larger picture area than the normal or the telephoto. The accompanying diagram shows that the angle of view, or angle of acceptance as it is often called, is greater for the shorter focal lengths and less for the longer lengths. The normal length gives us a normal picture, the wide-angle tends to distort the image, and the telephoto compresses the image. Actually, both the wide-angle and the telephoto scenes appear strange due to the position of the camera in relation to the subject.

The apparent distortion seen in the photographs opposite requires further explanation. Each of the photographs has two dimensions—width and height. Perspective is the element of a picture that gives us a third dimension—depth. It is controlled solely by the distance between the camera and the subject. The importance of subject distance can be seen in the photographs that follow.

28

Wide-angle camera, 40mm. *Normal camera, 100mm.* *Telephoto camera, 240mm.*

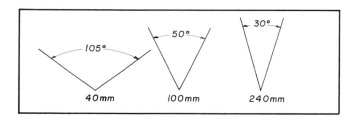

The angle of acceptance decreases with longer focal lengths.

Below left: This photograph was taken with a long focal-length lens. Center: Here the position was the same; only the lens was changed to a short focal length. Notice that in this and the photograph taken with the long focal-length lens, the size relationship of the subject to the background is the same. Below right: Now the camera is moved nearer to the subject. The lens is the same one used in the previous photograph, yet the size relationship between the subject and the background has changed radically.

LENS INTERCHANGEABILITY

A difficulty with our simple camera is the lack of lens interchangeability. The fixed-lens camera does not allow the photographer to choose the lens desired on the basis of the image size he wishes to photograph. The refined camera allows lens interchangeability so that from a specific point the photographer can select image size.

Below are three modern lenses, for one camera, which compare in angle of acceptance to our simple cameras. The difference in focal length between a normal pinhole camera and the normal lens below is due to the change in negative size. The negatives for our simple cameras were much larger than the 35mm negative covered by the lenses below. As negative size decreases so does the needed focal length to cover the same angle of acceptance.

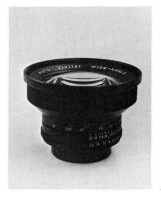

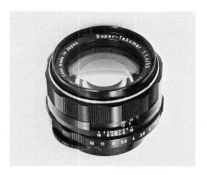

Normal 50mm.

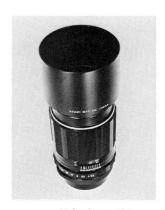

Wide-angle 20mm.

Telephoto 135mm.

95-degree angle of view.

Lens interchangeability provides choice of image size with one camera, as shown in the photographs on this and the page opposite.

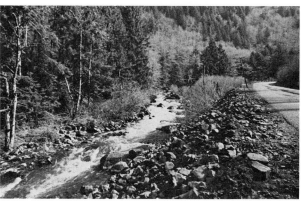

30

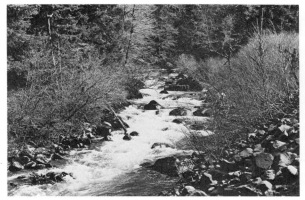

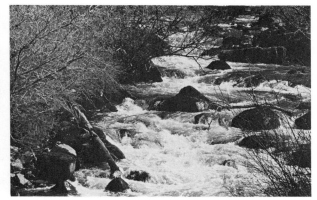

46-degree angle of view. *18-degree angle of view.*

THE ZOOM LENS

The zoom lens offers the advantage of allowing the photographer to select various image sizes with only one lens. The zoom lens is really a series of focal lengths built into one lens. Pictured below is a Vivitar lens with a relative aperture of ƒ/3.8 and 121 focal lengths from 85–205mm. Photographs using 4 of those 121 possible focal lengths are shown here.

85mm

135mm

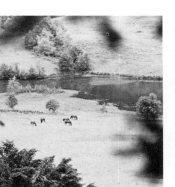

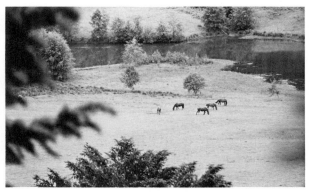

180mm

205mm

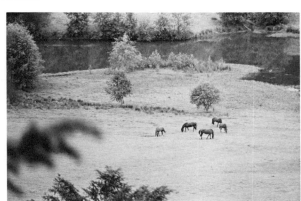

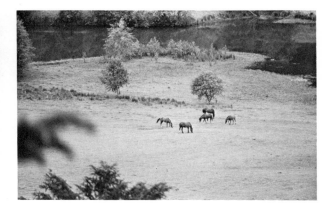

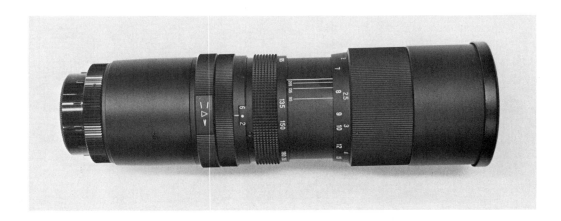

BUILDING A ZOOM CAMERA

It is possible to build a zoom-lens camera which allows for the selection of any focal length within the limits of the camera housing. Marks on the side of the model shown indicate the various settings from 105–180mm. Exposure time must be increased slightly as the longer focal lengths are used. This can be worked out by calculating the relative aperture for each focal length and using the scale given in Phase Two for the correct exposure times.

Right: Side view of the zoom-lens camera, showing the various focal length settings. Far right: Front view of the zoom-lens camera with aperture of f/365.

OBJECTIVES — PHASE THREE

1. To construct a camera with a normal focal length.
2. To construct a camera with a short focal length.
3. To make comparison photographs showing the difference in angle of view of three focal lengths.
4. To understand that perspective is changed by subject distance, not by focal length.
5. To understand that a zoom lens is one in which the focal length can be varied.

FOR FURTHER REFERENCE

See *Petersen's Photographic Magazine,* September, 1972, for an article on building a wide-angle camera.

The Camera by the editors of Time-Life has more material on focal length.

THE CAMERA—A HISTORY

The tripod mount added to our wide-angle camera was a simple, yet useful, refinement. From the earliest use of the camera obscura to the present, cameras have undergone continuing improvement. Following are some of the major stepping stones that have given us the cameras we know today—or that we will know after we finish Phase Four.

11th C. Camera obscura, a darkened room or tent, was used by the Arabs. (See page 15.)

16th C. Girolamo Cardano substituted a lens for the pinhole in camera obscura. The lens provided a more brilliant image.

18th C. Camera obscura became portable. One of the first portable models was designed by Johann Zahn, a German monk. It had a focusing lens with an adjustable aperture and a mirror that cast the image onto a screen on the top—much like today's single-lens reflex camera.

1826 Joseph Niépce, a Frenchman, used a camera much like Zahn's to produce the first picture on light-sensitive material. It was a bit slower than our kitchen camera. His first exposure was eight hours.

1840 An $f/3.6$ lens was designed and built by Josef Petzval, an Austrian. This fast lens cut exposure times to less than a minute. The lens was used in a type of heavy view camera designed by Peter von Voigtlander.

1861 The first focal-plane shutter was used by William England.

1887 The first leaf shutter was used by Edward Bausch.

1888 The first popular hand camera was introduced by George Eastman, an American. It was loaded at the factory with enough film to take 100 exposures, exposed by the customer, and returned for developing. With the advent of the small camera, human activity could be documented realistically.

1925 Oskar Barnack's Leica Camera was exhibited at the Leipzig Fair. It used 35mm film and took 36 exposures.

1927 Twin-lens Rolleiflex introduced.

1948 Edwin Land introduced the Polaroid "snap it—see it" camera.

1972 Popular cameras with many refinements became pocket size.

1975 Cameras with electronic exposure systems became the "in" refinement.

THE REFINED CAMERA

This 35mm single-lens reflex camera has a multitude of refinements not found in the kitchen camera. Some of them can be seen, but many more are hidden in the camera's interior. The only characteristics shared by the 35mm SLR and the simple camera are that both are a lighttight box and both have an aperture.

The variety of cameras available today can be grouped in many ways, according to type of shutter, style of viewing system, or film size.

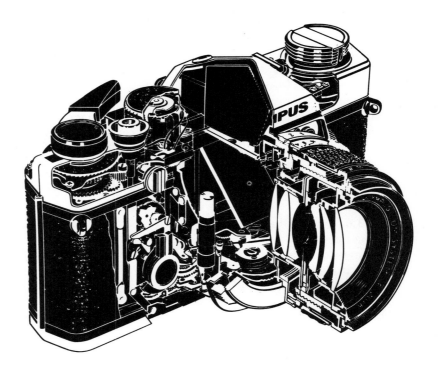

The refined camera has the same basic characteristics as the kitchen camera, but inside are a multitude of improvements.

THE SHUTTER

Your finger was the shutter in the kitchen camera. It was a controller of the time that the paper was exposed. The shutter on modern cameras usually gives times of one second, a half second, a quarter second, an eighth second, and so on, each succeeding setting half as long as the previous. Shutters may be divided into two main groups, the leaf shutter and the focal-plane shutter.

1. *The between-the-lens or leaf shutter*
The leaf shutter is placed between elements of the lens and is made of small overlapping blades of steel powered by a spring. The leaf shutter has the advantage of being very quiet, and it can be used with electronic flash at all shutter speeds. Its main disadvantage is that if interchangeable lenses are used with leaf shutters, the cost of the lens is increased, as the shutter must be built into each lens.

2. *The focal-plane shutter*
The focal-plane shutter is placed just in front of the film and is made of rubberized cloth or metal in two parts, which act like curtains to form an adjustable opening that slides across the film. A slow speed setting would have a wide opening in the curtain and a fast setting would have a much narrower opening. A focal-plane shutter tends to be noisy and cannot be used at all shutter speeds with electronic flash. Due to its position next to the film, it allows the viewer to compose his image through the picture-taking lens, which is impossible with the leaf shutter, except in the view camera or in cameras with special masks to protect the film when the shutter is open.

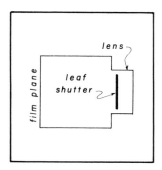

The leaf shutter is positioned next to the lens.

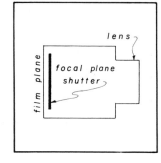

The focal-plane shutter is positioned next to the film.

VIEWING SYSTEMS

One objection you may have had to the kitchen camera was that you had no way of accurately composing or viewing the subject you were trying to photograph. This is the principal reason for a viewing system in a modern camera. (It also allows the photographer to focus on the subject at the same time he is viewing it—another refinement the kitchen camera did not have.) There are four types of viewing systems.

1. The simple viewfinder. This is a separate window through the camera, which may or may not be coupled with the focus mechanism (when coupled it's called a rangefinder). It is bright and works well in dim light. Since it is a separate window, one does not see exactly what the taking lens sees. This is called parallax error.

2. Single-lens reflex. In this system, the viewing is done through the taking lens. There is no parallax error, but the image is often not very bright. It is a bit slower to focus than the viewfinder with coupled rangefinder. The necessary prism makes it a more cumbersome system and its mirror is noisy.

3. Twin-lens reflex systems are really two separate lens systems. One is for taking the picture and the other for viewing. It is generally a waist-level viewing system, as compared to the systems above which are used at eye level. There is a parallax problem. The system is quiet, as the mirror does not pop up and down as in the SLR system. The image on the viewing screen is reversed from left to right, which takes some getting used to.

4. View camera. Here one views the image on a ground glass at the position of the film plane. The image comes directly through the lens and is thus reversed and upside down. No parallax error problem here, but the image cannot be seen when the film is in place. The camera is bulky and the viewing screen is not very bright. Not a hand-held camera.

Simple viewfinder system. *Single-lens reflex system.*

Twin-lens reflex system. *View camera system.*

CAMERAS GROUPED BY FILM SIZE

1. Subminiature film format
Film size: from 9.5mm to 16mm
Shutter: leaf or single blade behind-the-lens
Viewing system: viewfinder
Cameras using this film size range from ultraminiature ones using film only 9.5mm wide to the new pocket cameras using the drop-in cartridge in the 110 film size. Some subminiature cameras have built-in exposure meters, some have interchangeable lenses, and some have a focusing system. Their advantage is their small

size which fits pocket or purse. Their disadvantage lies in the small film size which does not allow extreme enlargements. Many of these cameras do not provide for adjustment of aperture and shutter speed.

Examples: Kodak Pocket Instamatics, Minox, models BL and C; Minolta's 16-QT

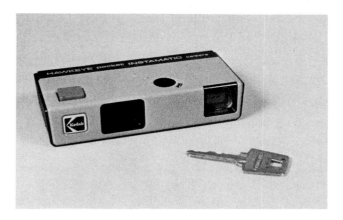

Subminiature film camera.

2. Miniature film format
Film size: 35mm
Shutter: leaf or focal-plane
Viewing system: viewfinder or single-lens reflex

This is the most popular camera size and therefore has the widest range of models from which to choose. Some with the rangefinder system have the focal-plane shutter, as in the Leica M5; others with the viewfinder system have a leaf shutter, as in the Rollei 35. The majority are SLR with through-the-lens viewing systems, focal-plane shutters, and lens interchangeability. Most have behind-the-lens metering systems for correct film exposure, with the trend toward automatic exposure systems in which the photographer sets the shutter speed or the aperture and the camera automatically sets the other factor.

Examples: Honeywell Pentax Spotmatic F, Nikkormat EL, Leica M5

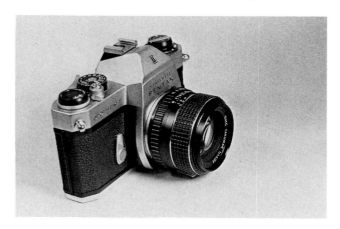

35mm format camera.

37

3. Roll-film format
Film size: Includes 127, 120, 220, and 620 roll film
Shutter: leaf usually, some may have focal-plane shutters
Viewing: viewfinder, single-lens reflex, or twin-lens reflex

Cameras in this group range all the way from simple box cameras, with very few refinements beyond the kitchen camera, to cameras costing $1000 or more. Most box cameras have only one aperture setting (f/8 or f/11) and only one shutter speed (1/60 sec.). Their low cost and simple operation make them popular.

More versatile are the twin-lens reflex cameras using 120, 220, or 127 roll film. Only one TLR offers lens interchangeability with a wide variety of lenses—the Mamiya C220 or C330. Few TLRs have metering systems. Lower-priced models without metering systems start at around $100.

The single-lens reflex roll-film cameras provide large film format with the accuracy of through-the-lens viewing. Many have interchangeable backs to accept sheet film or Polaroid film. Physical size is large, thus they are often heavy. Metering systems for some models have been developed. Cost range is from $550 to over $1000.

Last in this group are the press cameras using roll film. The press camera offers large film format with the speed of rangefinder focusing at a lower cost than the single-lens reflex roll-film camera. The camera is heavy (most weigh around five pounds) yet popular for wedding and sport photography. Some offer lens interchangeability.

Examples: Yashica D (TLR), Norita 6X6 (SLR), Rapid Omega 100 (press)

Twin-lens reflex roll-film camera.

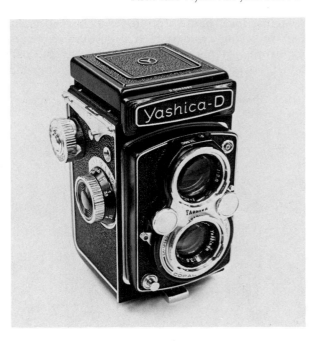

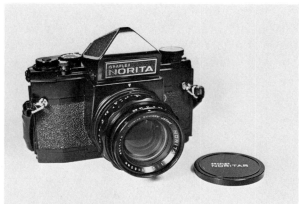

Single-lens reflex roll-film camera.

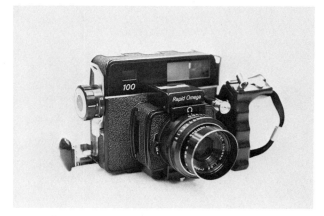

Press camera using roll film.

4. Sheet-film format
Film size: 4 × 5 and larger sheet film
Shutter: leaf
Viewing system: view camera (through-the-lens)

The view camera offers accurate viewing through the lens, very large film sizes, and accurate ground-glass focusing. There is no parallax error. The camera is bulky, and the image on the ground glass is so dim that the photographer must use a cloth over his head and the camera back when focusing and composing the photograph. The inverted image is difficult to work with and is lost from view when film is in place. The camera is best used in the studio situation and must always be used on a tripod for support. Cost for a 4 × 5 view camera starts at about $250.

Examples: Toyo View Camera, Calumet C1, Sinar-p

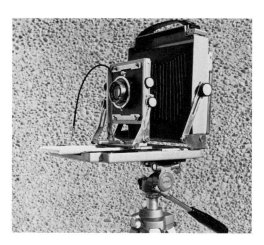

Cut or sheet film is used in the view camera. This camera offers large film format and a bellows for perspective correction.

39

CAMERA SUMMARY CHART

Viewing System	Viewfinder System	SLR System	TLR System	View Camera
35mm film	●	●		
Roll film	●	●	●	
Sheet film				●
Focal-plane shutter	●	●		
Leaf shutter	●		●	●
Small size—easy to carry	●	●	●	
Cost under $100 with lens	●	●	●	
Easy to operate	●	●	●	
Quick to focus	●			
Interchangeable backs	●	●		●
Built-in meter	●	●	●	
Meters through taking lens	●	●		
Interchangeable lens	●	●	●	●

OBJECTIVES — PHASE FOUR

1. To learn some facts about the development of the camera.
2. To explain the difference between leaf and focal-plane shutter.
3. To list the advantages and disadvantages of four viewing systems.
4. To know the basic camera formats according to film size.

FOR FURTHER REFERENCE

See *The Camera* by the editors of Time-Life.

See *Petersen's Photographic Magazine,* February, 1973, for a comparison of the single-lens reflex cameras and cameras with coupled rangefinders.

CAMERA CONTROLS

The refined camera gives us many advantages that the kitchen camera does not. Most important of these are the controls that the photographer has over exposure and focusing. The exposure of film can be adjusted two ways:

1. By changing the size of the aperture
2. By changing the amount of time the shutter is open.

With each control, the total exposure can be increased or decreased. In addition, these controls allow the photographer to make his photographs more realistic and more appealing. His photographs can say what he wants them to say.

The controls for exposure and focusing on the refined camera.

Focusing control

Aperture control

Shutter control

APERTURE AND LIGHT

Our simple camera had a fixed aperture; we could not change the size of the opening. On the refined camera, the size of the opening can be changed by turning a ring on the lens barrel. This adjusts a diaphragm of thin metal leaves, which in turn control the amount of light entering the camera. Remember that the largest opening is the basis for determining the relative aperture or speed of a lens.

$$\text{Diameter of Aperture}\ \overline{\big)\ \text{Relative Aperture} \atop \text{Focal Length of Lens}}$$

All the other aperture settings are calibrated on the basis of the relative aperture. Each smaller opening admits one half the amount of light of the previous larger opening. Standard f/numbers are: f/1, f/1.4, f/2, f/2.8, f/4, f/5.6, f/8, f/11, f/16, f/22, f/32, f/45, and f/64. Not all lenses will have all of these "stops," as they are called. If the relative aperture of a lens is f/5.6, then it would not have a setting of f/4; it would only have settings of f/5.6 and smaller. In reality, all f/numbers indicate the relationship of their size to the focal length, and the speed of a lens is always indicated by the largest opening.

The accompanying photographs show the effect of the aperture as the diaphragm is closed down. The amount of time the shutter was open was the same in all photographs. The correct exposure is the combination of 1/30 sec. and an f/5.6 aperture.

f/1.4, 1/30 sec. *f/2, 1/30 sec.*

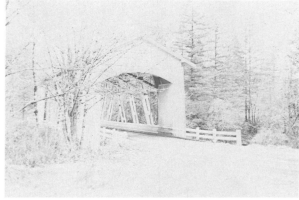

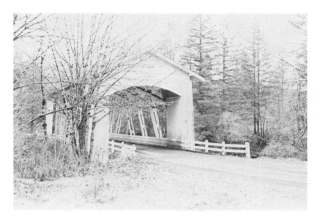

f/2.8, 1/30 sec.

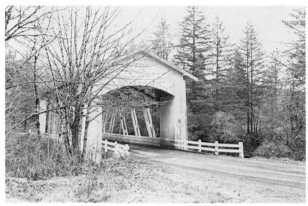

f/4, 1/30 sec.

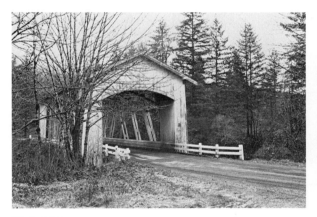

f/5.6, 1/30 sec.

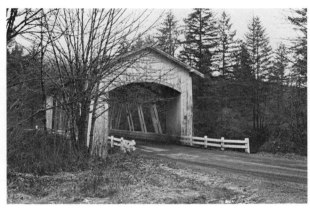

f/8, 1/30 sec.

f/11, 1/30 sec.

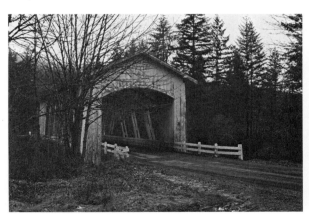

f/16, 1/30 sec.

An f/number is a relationship of aperture diameter to focal length. As the aperture diameter gets smaller, the ratio changes. Smaller apertures have larger f/numbers.

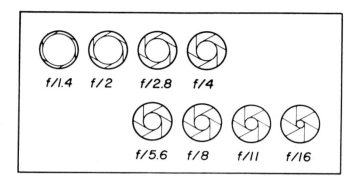

APERTURE AND DEPTH OF FIELD

The aperture has one other important function in addition to its function as a controller of light for proper exposure. The aperture controls depth of field. Depth of field may be defined as the field of distance in the picture area that will appear in focus in the photograph.

A greater depth of field is produced when a smaller f/stop is used. Using f/1.4 may produce a depth of field of 10 ft., while f/11 will produce a depth of field greater than 10 ft.

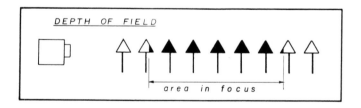

In the following diagram, point A is sharply focused on the film plane while point B, nearer the camera, is not in focus as the circles of confusion are too large at the point at which they hit the film plane to register sharply.

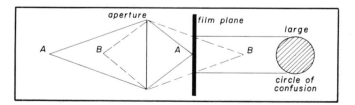

When the aperture is closed down to a smaller opening, the light rays from point B form smaller circles of confusion on the film plane and are in sharper focus. The depth of field has been increased to cover both points A and B.

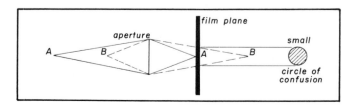

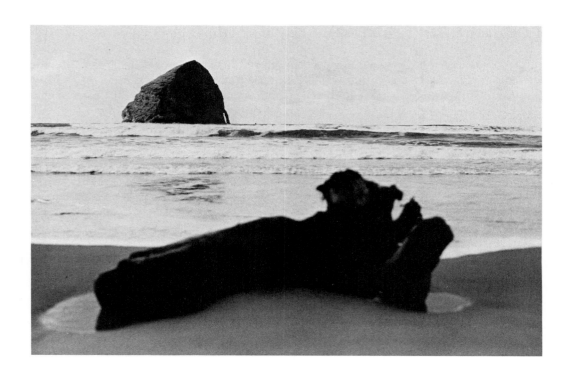

The photograph above shows the rather limited depth of field when using an aperture of f/1.4. The one below shows the increased depth of field obtained when the aperture is changed to f/16. In neither case was the subject distance or focal length of the camera changed. Both of these factors also influence depth of field.

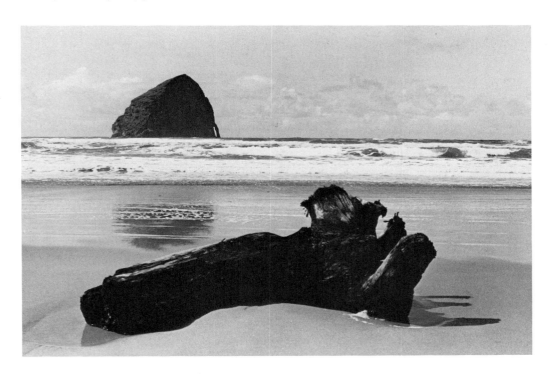

FOCAL LENGTH AND DEPTH OF FIELD

If we check back to our simple-camera photographs, we can see that the area in focus in the wide-angle photograph is from the front of the camera to infinity. As the focal length was increased depth of field decreased. The short focal length gives a greater depth of field than does the telephoto. This is clearly seen in the two accompanying photographs. The first was taken with a 20mm wide-angle lens and the second with a 135mm telephoto lens.

Below: Great depth of field with a short focal-length lens. Bottom: Depth of field decreases with longer focal-length lenses.

SUBJECT DISTANCE AND DEPTH OF FIELD

A third factor affecting depth of field is the distance from camera to subject. Depth of field is greater the farther you are from the subject and decreases as the camera is brought closer to the subject. The following chart shows the increasing depth of field as subject distance increases when using a normal lens on a 35mm camera.

Distance to subject	1′ 6″	10′	30′
Depth of field	1′ 5.5″ to 1′ 6.5″	8′ 1.9″ to 12′ 11.2″	17′ 8.3″ to 100′ 1.3″

Both of the photographs were taken with the same lens set at the same aperture. In the one on the left, the camera-to-subject distance was 18 in. In the one on the right, the camera-to-subject distance was 30 ft. (Lens: 55mm.)

Depth of field increases as distance between camera and subject increases.

 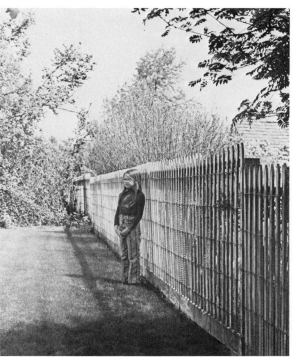

In the photograph below, the distracting fence becomes a soft pattern on the climbing plane. Here a foreground element is virtually eliminated by using a large aperture and a long lens. Exposure was 1/250 sec. at $f/3.5$ with a 135mm lens coupled to a 2× extender. A 2× extender doubles the focal length of a lens and a 3× extender triples the focal length. In both cases, the light has further to travel making the lens slower.

Control of depth of field can soften a distracting foreground element.

The photograph of the flower, torch ginger, on page 49 illustrates the use of all three camera controls to decrease depth of field. The limited camera-to-subject distance, the large aperture, and the avoidance of a wide-angle lens all contribute to the elimination of a distracting background. Emphasis is placed on the subject. The hexagon shapes in the background are reflections from the diaphragm of the camera as the subject is backlighted, that is, the camera is facing the sun.

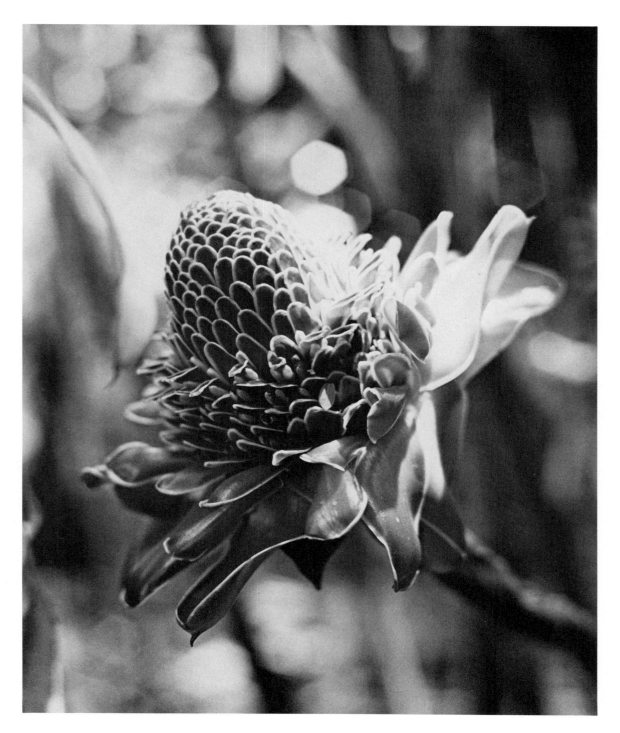

This photograph of the flower, torch ginger, was made using all the camera's controls to limit depth of field. Exposure was 1/250 sec. at f/1.4.

Depth of field, then, may be controlled in three ways:

1. With the aperture—small apertures give the greatest depth
2. With lens focal length—shorter focal lengths give greatest depth
3. With subject distance—the further the camera is focused the greater the depth of field.

READING DEPTH OF FIELD

Most lenses that can be focused have a distance scale on them that indicates subject distance in both feet and meters. In the first photograph below, the camera was focused at 30 feet, or 10 meters.

In combination with this distance scale, some lenses have other scales that give the depth of field at each aperture setting.

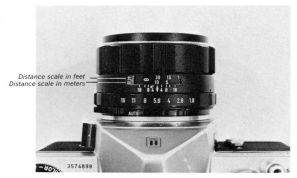

On this normal lens for a 35mm camera, the diamond points to f/16 and the distance setting is 7 ft. By reading 16 to the left and right of the diamond and then the distance scale across from 16, we find that the depth of field is from 5 ft. to 10 ft.

While this 35mm lens reads the same depth of field as the normal lens, it has an added advantage. By using f/8 or higher, and setting the distance scale on 15 ft., one has virtually unlimited depth of field. Essentially, we have converted the lens into a fixed lens. The short focal length plus the small f/number and the not-too-close distance setting combine to give great depth. This feature is very helpful to photojournalists who do not have time to focus before every exposure.

50

HYPERFOCAL DISTANCE

The distance scale on a camera lens is useful in providing yet another method of increasing depth of field through the use of selective focus in relation to hyperfocal distance. Hyperfocal distance is the distance between the camera and the first point of sharpness with the lens focused at infinity. Depth of field is increased by focusing at the hyperfocal distance. The depth of field then becomes one half the hyperfocal distance greater. In the diagram below, the hyperfocal distance is 30 ft. If we keep the same aperture and focus the lens at 30 ft. rather than at infinity, the depth of field will extend from 15 ft. to infinity. We will have gained an additional 15 ft. in the depth of field (see diagram).

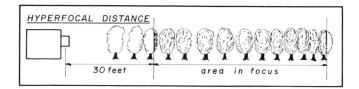

With the lens set at infinity, you can determine the hyperfocal distance by reading the depth-of-field scale on the lens. Remember that this depth-of-field scale is based on the aperture you are using. In the photograph at left, the hyperfocal distance is 30 ft. with an aperture of f/8. By setting the focus at 30 ft. rather than infinity, the depth increases and is now 15 ft. to infinity as shown in the photograph below left.

51

The shutter is also a controller of light.

 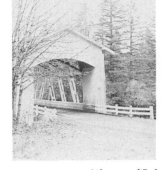 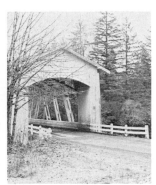

1/4 sec., f/5.6 1/8 sec., f/5.6 1/15 sec., f/5.6

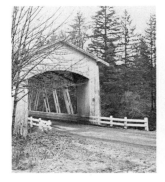 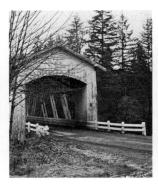 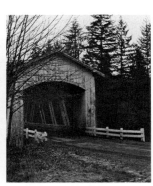

1/30 sec., f/5.6 1/60 sec., f/5.6 1/125 sec., f/5.6

1/250 sec., f/5.6 1/500 sec., f/5.6 1/1000 sec., f/5.6

THE SHUTTER AND LIGHT

The second control the photographer has over exposure is his control over the length of time that light is allowed to enter the aperture. The shutter is the controller of this length of time.

As indicated earlier, shutters are either the leaf type, situated between or behind the lens elements, or the focal-plane type, positioned just in front of the film plane. Shutters are very precise and are able to control the exact length of time that the film is exposed. Most shutters have settings from 1 second to 1/1000 sec. Some will have a B setting, standing for Brief exposure; the shutter remains open for as long as the shutter release is held down. Some cameras have a T setting, for Time; the shutter will open when the shutter release is pressed and will close when the shutter release is pressed again.

Common shutter settings are: 1 second, 1/2 sec., 1/4 sec., 1/8 sec., 1/15 sec., 1/30 sec., 1/60 sec., 1/125 sec., 1/250 sec., 1/500 sec., and 1/1000 sec. Note that each is half the duration of the previous setting.

The photographs on page 52 show the effect of each shutter setting. All exposures were made at $f/5.6$. The correct exposure is the combination of 1/30 sec. at $f/5.6$. Shutter settings for longer or shorter periods of time resulted in incorrect exposures. Photographs that received from 1/15 sec. to 1 second are light because the negative was very dark from overexposure. Photographs that received 1/60 sec. to 1/1000 sec. are darker because the negative received too little light. The photographs look very similar to the ones that show the effect of each aperture setting (see pages 42-43). In each case, the aperture or the shutter setting becomes the method of controlling the amount of light that strikes the film.

THE SHUTTER AND ACTION

In addition to the shutter's function as a controller of light, the shutter can be used to create dramatic photographic effects. Its ability to freeze action or to prolong action in a blur of movement makes it one of the most creative controls on the camera. Basically, a slow shutter speed will blur movement while a fast shutter speed will stop movement.

If the camera is moved to follow a movement, and a slow shutter speed is used, the movement is frozen and the background is blurred. This same panning movement with a fast shutter will freeze both the movement and the background.

Generally, a slow shutter speed may be used to stop action that is coming toward or moving away from the camera. A faster shutter speed is needed to stop action moving parallel with the camera.

FOCUSING

A final control not found on the kitchen camera is the focus control. It moves the lens so that the subject is sharply projected onto the film plane. The kitchen camera had a very small relative aperture that gave great depth of field—focusing was not critical. With lenses that have great light-gathering ability but little depth of field, focusing is important—especially when subjects are very close to the camera. Focusing can be accomplished in one of three ways.

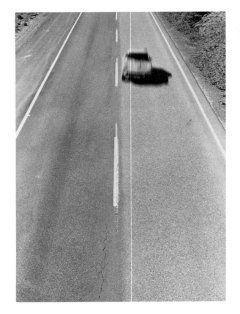 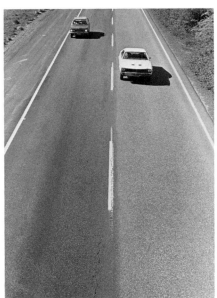

Slow shutter speed setting. *Fast shutter speed setting.*

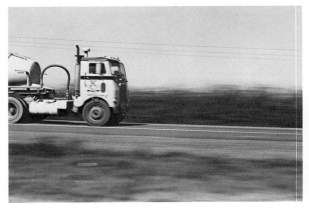

Panning with slow shutter. *Panning with fast shutter.*

Of the three ways, zone focusing is the least precise. The distance from camera to subject is estimated and the appropriate setting is made on the lens. Symbols usually indicate close, medium, and far distances.

Ground-glass focusing is found on the TLR and SLR cameras and also on the view camera. A knob is turned which moves the lens away from or toward the film plane until the image is sharp on the screen. Often the image is dim and difficult to focus, so a magnifier is added to assist the photographer. The camera, ground-glass screen, and photographer's head may be draped with a cloth to make viewing and focusing easier with view cameras.

Rangefinder focusing is the third system. The double image it provides is much faster to focus, especially under dim light conditions. This system is used in press cameras, and some miniature and subminiature cameras.

CAMERA OPERATION

The following pages will assist in locating the camera controls discussed in this section. Three different film-format cameras are presented—the single-lens reflex using 35mm film, the twin-lens reflex using 120 roll film, and the view camera using 4″ × 5″ sheet film.

35mm SINGLE-LENS REFLEX

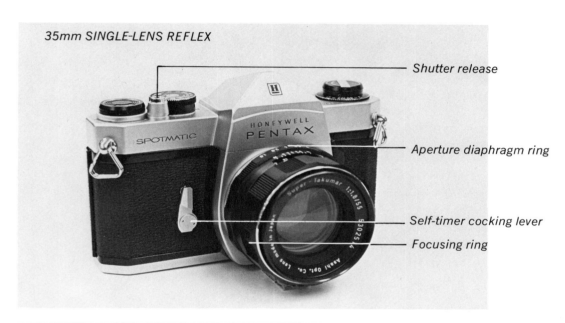

Shutter release

Aperture diaphragm ring

Self-timer cocking lever

Focusing ring

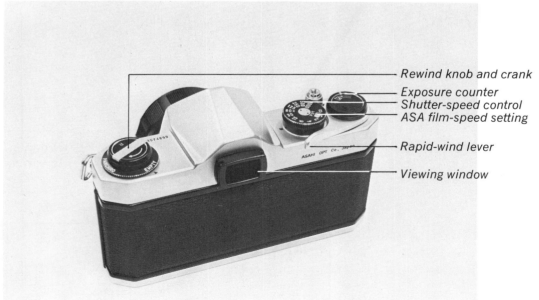

Rewind knob and crank

Exposure counter

Shutter-speed control

ASA film-speed setting

Rapid-wind lever

Viewing window

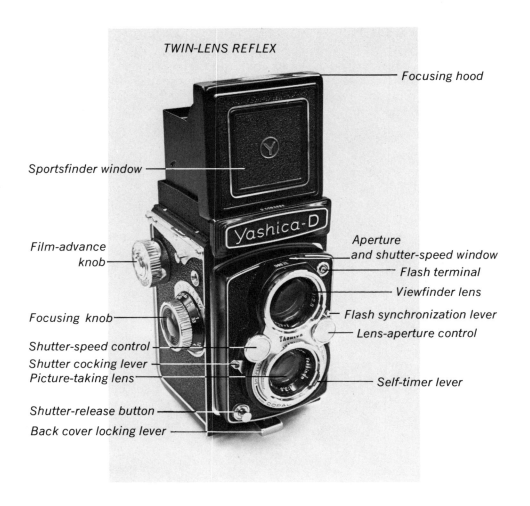

TWIN-LENS REFLEX

Focusing hood

Sportsfinder window

Yashica-D

Film-advance knob

Aperture and shutter-speed window

Flash terminal

Viewfinder lens

Focusing knob

Flash synchronization lever

Lens-aperture control

Shutter-speed control

Shutter cocking lever

Picture-taking lens

Self-timer lever

Shutter-release button

Back cover locking lever

A major advantage of the view camera is that raising, lowering, swinging, and tilting the lens in relation to the film plane allows the photographer to correct focus, distortion, and perspective problems.

The view camera corrects perspective.

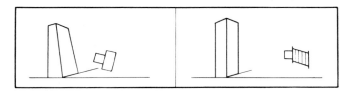

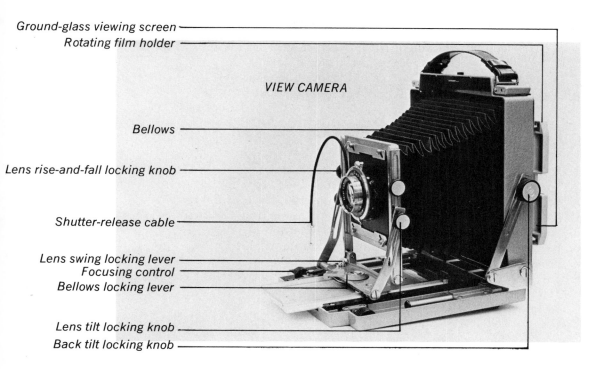

Ground-glass viewing screen
Rotating film holder

VIEW CAMERA

Bellows

Lens rise-and-fall locking knob

Shutter-release cable

Lens swing locking lever
Focusing control
Bellows locking lever

Lens tilt locking knob
Back tilt locking knob

We have looked at various camera types in Phase Four and camera controls in Phase Five and are now ready to move from the kitchen camera to the refined instruments of today. There are certain good habits that a photographer should acquire regarding camera usage that are certain to give better results.

1. Load the camera in the shade to avoid the possibility of bright sun damaging the film.
2. Keep the camera out of the sun when not in use. Do not store it in hot places. Heat is harmful to both camera and film.
3. When loading, make certain that the film is properly threaded and advancing smoothly.
4. Be certain that you have properly adjusted the camera for the type of film you are using.
5. Focus carefully and check all settings before you shoot.
6. Don't waste film. Film has tiny silver particles as part of the emulsion. Silver is a limited resource.
7. Use the highest shutter speed possible within the limits of what you are trying to accomplish. This will give you sharper photographs.
8. Hold the camera firmly when shooting. Brace your arms against your body. Press the shutter release slowly so that you do not jar the camera. Use a tripod when possible.
9. Think before you shoot. If the image does not mean anything to you, it won't mean anything to others either.
10. Do not open the back of the camera until the film is rewound or in such a position that it will not be exposed to light when the back is opened.

11. Keep all equipment clean. Keep fingers off lenses and out of the inner mechanisms of the camera.
12. Learn the operation of the camera so that you can load it and operate the controls without looking at them.

OBJECTIVES — PHASE FIVE

1. To know the three principal camera controls.
2. To understand the two functions of the aperture.
3. To know how to utilize the three controls of depth of field.
4. To make use of hyperfocal distance to increase depth of field.
5. To understand the two functions of the shutter.
6. To know how to utilize the shutter to stop and blur action.
7. To know the three focusing systems.
8. To become familiar with the aperture, shutter, and focusing controls of the SLR, TLR, and view cameras.
9. To know good practices in camera operation.

FOR FURTHER REFERENCE

See *The Camera* by the editors of Time-Life for more on camera controls.

See *The Here's How Book of Photography* (Eastman Kodak) for an excellent discussion of depth of field.

See *Camera and Lens: The Creative Approach* by Ansel Adams (Morgan and Morgan) for more on the operation of the view camera.

EXPOSURE AND FILM

PART TWO

EXPOSURE VALUE

The refined camera provides us with two basic methods of controlling the amount of light that strikes the film—the aperture and the shutter. These two controls are designed to work together in such a relationship that one will compensate for the other. Should we wish to use the aperture to gain a certain depth of field, we can compensate for the small amount of light admitted by setting the shutter for a longer period of time. Should we wish to stop a subject movement by using a fast shutter, which admits little light, we can compensate by increasing the size of the aperture. This interrelationship between aperture and shutter is most vital to total utilization of the refined camera.

To illustrate, let us assume that we have a film that requires an arbitrary value of 11 to expose it properly. We will assign to each aperture and each shutter setting a number. The lower the number the more light admitted. The larger the number the smaller the amount of light that strikes the film.

Aperture	f/1.4	f/2	f/2.8	f/4	f/5.6	f/8	f/11	f/16
Arbitrary Aperture Value	1	2	3	4	5	6	7	8
Shutter Speeds:	1/1000	1/500	1/250	1/125	1/60	1/30	1/15	1/8
Arbitrary Shutter Speed Value	10	9	8	7	6	5	4	3

Now we need only to add an aperture value and a shutter value that will equal the value of 11 to properly expose our film. You can see that there are many combinations that equal a value of 11. In fact there are eight of these combinations. We call each of these combinations exposure values. The photographs on the following page show the use of these exposure values. All received the same amount of light, as all settings equaled the same exposure value.

If the film is given an exposure value of less than 11, it will receive more light than might be desired. An exposure of f/2.8 at 1/30 sec. would give an exposure

The right combination of aperture and shutter speed will give the same exposure value.

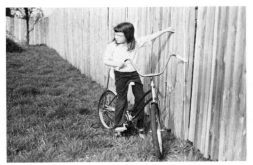

f/1.4, 1/1000 sec.

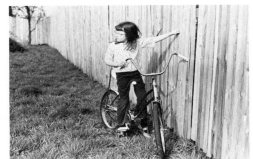

f/2, 1/500 sec.

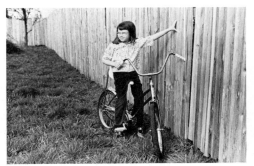

f/2.8, 1/250 sec.

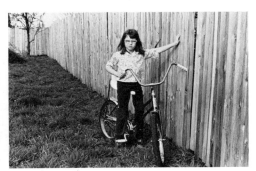

f/4, 1/125 sec.

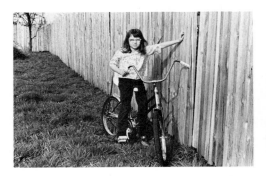

f/5.6, 1/60 sec.
f/11, 1/15 sec.

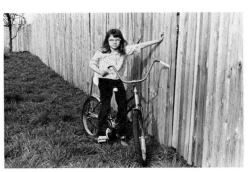

f/8, 1/30 sec.
f/16, 1/8 sec.

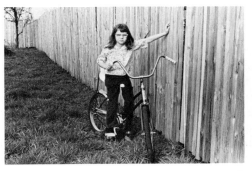

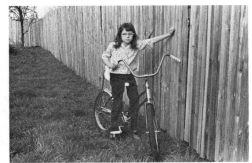

value of 8. Our negative would be very dark and the resulting positive would be very light.

Should we give the film an exposure of 14—*f*/8 at 1/250 sec.—then our negative would be too light and the resulting positive would be too dark. It is possible, however, to correct or compensate for slight over- and underexposure of the film by exposing for a longer or shorter amount of time when making prints in the darkroom.

There may be times when we want to change the exposure value to bring out dark areas of the subject, that is, to record detail in an area of a shadow. The exposure value is not sacred. It is, however, a good starting point for getting a good photographic image.

In setting the aperture and shutter speed for the proper exposure, it must be remembered that if you change one factor you must also change the other to maintain proper exposure. If the aperture is stopped down, that is, the opening made smaller, we must compensate by increasing the length of time the shutter remains

Below left: Too much exposure will result in a light print. Below right: Too little exposure will result in a dark print.

open. If, on the other hand, we open up the lens aperture, that is, increase the size of the opening, then we must decrease the amount of time the shutter remains open. The following will clarify:

1. The correct exposure is $f/5.6$ at 1/60 sec.
2. We wish to stop down the lens to $f/8$ for increased depth of field. This decreases the light striking the film.
3. We must now lengthen the time the shutter is open from 1/60 sec. to 1/30 sec. to compensate for the smaller aperture.
4. If the lens is stopped down from $f/5.6$ to $f/11$ (two stops), then the shutter speed would be lengthened by two settings, from 1/60 sec. to 1/15 sec.
5. Should the lens be opened up two stops, then the shutter speed would need to be decreased by two settings to retain the same exposure value—$f/2.8$ at 1/250.

The combination of shutter speed and aperture chosen will depend on several factors.

1. The depth of field desired.
2. The desire to stop or blur motion.
3. The sensitivity of film.
4. How much we might want to deviate from a standard exposure value to capture detail in shadows or retain very bright areas.

These last two items will be covered in the next two phases.

OBJECTIVES — PHASE SIX

1. To understand the expression "exposure value."
2. To understand the interrelationship of aperture and shutter speed.

Try completing the following:

a. 1/60 sec at $f/8$ = 1/30 sec. at _____.

b. 1/125 sec. at $f/11$ = _____ at 1/250 sec.

c. 1/1000 sec. at $f/2.8$ = _____ at $f/4$.

d. 1/500 sec. at $f/8$ = _____ at $f/16$.

a. $f/11$ b. $f/8$ c. 1/500 sec. d. 1/125 sec.

FOR FURTHER REFERENCE

See *The Camera* by the editors of Time-Life for more on exposure.

FILM

Enlarging paper was used in the simple camera in the place of film, for we wanted a sensitive material that could be handled easily under darkroom safelight conditions. The paper was slow, that is, not as sensitive to light as modern films, and thus required a fairly long exposure time. Modern refined cameras with their precise controls can use materials with much greater sensitivity.

Today, there is a great variety of films on the market. A brief history of the development leading to today's films is interesting if only to appreciate the remarkable changes that have taken place since the Englishman, Thomas Wedgwood, experimented with the making of negative prints by bathing paper in a silver nitrate solution and exposing it to light.

THE LATENT IMAGE—A HISTORY

A latent image is one that is not visible until a chemical solution is used to develop it. The images produced by Thomas Wedgwood in the early nineteenth century were not latent images, but rather immediately visible images. The solution-coated paper turned dark as it was exposed to light.

A brief history of the latent image follows:

1816　A Frenchman, Joseph Niépce, took pictures using a camera and paper coated with a silver chloride solution. It was only in negative form and he had no way to preserve it.

1826　Niépce recorded the first image on a pewter plate coated with bitumen. The unexposed portions of bitumen were washed away with only the areas hardened by light remaining. His exposure was said to have taken 8 hours and was called Heliography (sun-writing).

1837　Niépce later joined in partnership with Jacques Daguerre. In 1883 Niépce died and Daguerre modified his process and in 1837 produced the Daguerreotype. This was a copper plate coated with silver iodine. The plate was exposed for from 4 to 40 minutes and then heated in a box with mercury which combined with the silver iodide to form the image. The plate was then washed with common salt. Daguerre became a hero and everyone soon wanted to learn the process.

1839 Henry Fox Talbot entered the scene in England and reexamined Wedgwood's process. He could not make the image permanent until another Englishman, John Herschel, developed the use of hyposulphite of soda for fixing in 1839. This chemical washed away the surplus silver chloride. Talbot's results were called Calotypes and later Talbotypes and were the first true latent images. Talbot was able to make prints of his negatives using silver-chloride-coated paper. This was an advantage over the Daguerreotype, for the Daguerreotype was in itself a positive and could not be reproduced.

1851 In 1851 Scott Archer developed a wet-plate process by coating a glass plate with a cellulose nitrate solution which he then dipped into silver nitrate in the darkroom and uncovered only when he made the exposure. Although Archer died penniless, his collodion process was used for more than 30 years.

1860 The Ambrotype also became popular about this time. It was a collodion negative, bleached and mounted on a black background, which gave it the appearance of a positive. It was speedy, inexpensive, and popular for portraiture. The popular Tintype, using much the same process, was used a good deal during the Civil War.

1875 Dry plates were soon developed with a sensitive emulsion in a gelatin base. The photographer no longer had to carry heavy glass plates and chemicals with him. Dry plates could be manufactured in quantity. By 1880 amateur photography was blooming.

1888 George Eastman introduced his camera, which contained a roll of paper coated with a gelatin bromide emulsion. After exposure, the camera was sent back to the factory where the gelatin coating was stripped from the paper and mounted on glass. In 1889 he introduced the flexible celluloid film, which could be processed by the amateur himself.

1947 Film continued to be improved in the twentieth century. By 1947 the Polaroid process was introduced in which film was developed in the camera and a high-quality picture produced in a minute.

MODERN FILMS

Modern films are made using a cellulose-acetate base with coatings as indicated in the diagram. The light-sensitive crystals are spread in the gelatin of the emulsion layer. These silver bromide crystals exhibit no apparent change when exposed to light. They turn dark in the development process as they are converted into silver metal. The fixing process will remove those sensitive particles not exposed to light. The anti-halation coating keeps the light from bouncing back through the emulsion and causing halo reflections. It is a sort of sponge, absorbing the light.

66

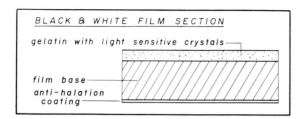

BLACK & WHITE FILM SECTION

gelatin with light sensitive crystals

film base

anti-halation coating

COLOR SENSITIVITY

The sensitivity of the film to the colors of the visible spectrum will depend on the addition of optical sensitizers or dyes. Films may be classified in the following groups according to color sensitivity.

Orthonon: No dyes have been added and thus they are sensitive to only violet and blue. These are highly specialized films.

Orthochromatic: Sensitive to violet, blue, and green. Again a specialty film used in the graphic arts.

Panchromatic: The most common type of film. Sensitive to the visible spectrum. All films that have ''pan'' in their names are panchromatic films.

Infrared: Sensitive to ultraviolet, blue-violet, deep red, and the invisible infrared radiation.

Orthochromatic film.

The photographs on this and the following page illustrate the color sensitivity of three of the above films.

Panchromatic film. *Infrared film.*

LIGHT SENSITIVITY

The color sensitivity of black-and-white film is one way of classifying films; another is the film's overall sensitivity to light. This is the most common classification of film. The light sensitivity, or speed of film, is controlled by the size of silver bromide crystals in the film's emulsion. Smaller crystals give the film a low sensitivity and produce slow film speeds. Larger crystals are used in faster films.

A number of systems have been developed to classify films according to their sensitivity. The first system was developed by Hurter and Driffield in 1890 and became known as the H and D curve. It became the basis for emulsions that gave predictable results. The measurement of exposure, development, and the image produced is known as sensitometry and is shown on the H and D curve. Today, it is called the characteristic curve and is useful in getting the most from your negative in terms of tonal range. (See Phase Twelve.)

The next system to be developed was the German DIN, for Deutsche Industrie Norm. In 1943 the American Standards Association developed its own system, which is known as ASA. The British have also developed a system of classifying films according to speed. It is abbreviated BSI.

The three systems are compared in the following chart:

ASA	12	25	50	100	200	400	800
DIN	12	15	18	21	24	27	30
BSI	22	25	28	31	34	37	40

Note that the ASA is arithmetical, so that an ASA 400 film is twice as fast as one of ASA 200 and thus would require only half as much light for an equivalent exposure. Both the DIN and BSI systems are logarithmical, so that an increase of three doubles the speed. Increasing from DIN 24 to 27 is the same as increasing from ASA 200 to 400. A version of the BSI system is arithmetical; its numbers correspond to the ASA system. The ASA and DIN systems are presently the two most widely used.

OTHER FILM CHARACTERISTICS

In addition to color and light sensitivity, there are other important characteristics of film. They are:

Definition—the overall impression one gets when looking at a print from a given negative. It is the composite of sharpness, resolving power, and graininess.

Sharpness—(also called acutance) the ability of a film to record a definite boundary between various areas in the photograph.

Resolving power—the ability to record fine detail. A test of resolving power would be how well a film can reproduce small, closely spaced lines.

Graininess—the granular structure or clumping of silver grains. Photographs with much grain have less definition because they are less sharp and have less resolving power.

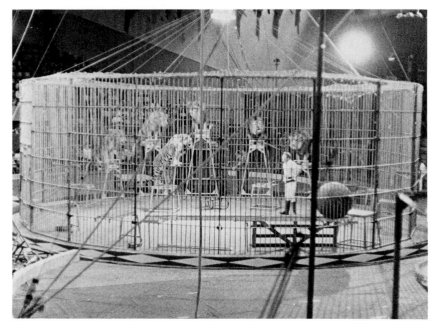

This circus scene lacks definition. There is little acutance and much grain.

This photograph was made from a negative having good definition. There is little grain. Detail and sharpness contribute to an overall impression of clarity.

COMMON BLACK-AND-WHITE FILMS

The following chart of black-and-white films includes most panchromatic films. It lists the most popular films in four categories based on light sensitivity.

SENSITIVITY GROUPING	ASA	SIZE (35MM OR ROLL)	CHARACTERISTICS
Slow Films			
Ilford Pan F	50	35mm	Good for brightly lighted scenes. Extremely fine grain. Rich gradation of tones.
Kodak Panatomic-X	32	Both	
H&W Control VTE Pan	80	Both	
Medium Speed Films			
GAF125	125	35mm	Much exposure latitude. Fine grain, general purpose films.
Ilford FP4	125	Both	
Kodak Plus-X Pan	125	Both	
Kodak Verichrome Pan	125	Roll	

SENSITIVITY GROUPING	ASA	SIZE (35MM OR ROLL)	CHARACTERISTICS
Fast Films			
Agfa Isopan Ultra ISU	400	35mm	Good latitude.
GAF 500	500	Both	Some grain. Good
Ilford HP4	400	Both	for dim light and
Kodak Tri-X Pan	400	Both	action requiring fast shutter.
Superfast Films			
Agfa Isopan Record	1000	35mm	Coarse grain. Use
Kodak Royal-X	1250	120	under very dim light.
Kodak 2475 Recording	1000/3000	35mm	

CHOOSING THE RIGHT FILM

A number of factors must be considered in choosing the correct film for a particular photographic assignment. Among them are:

The color sensitivity of the film. Should it be panchromatic, orthochromatic, infrared, or orthonon?

Speed. Will it be exposed under bright or dim light conditions? The film speed should be no greater than is necessary to avoid grain and preserve definition. (Unless grain is a desired characteristic.)

Note how two different films handle definition in the two photographs below. Left: The photograph of the barn door was taken on Kodak Plux-X, a medium-speed fine-grain film. This film exhibits good definition. Right: The Ferris wheel was taken on Kodak 2475 Recording film, an ultra-fast coarse-grain film. Note the lack of definition. Both were enlarged to the same degree.

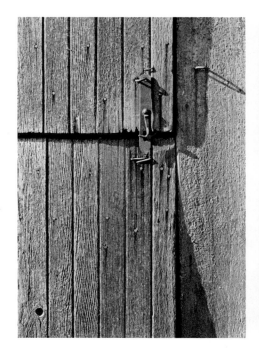 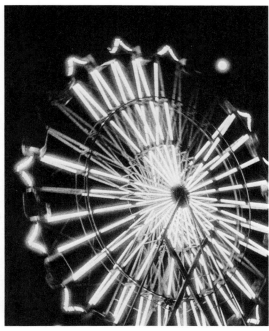

The photograph on the right represents a 4× enlargement. The one on the far right represents a 16× enlargement from the same negative. Notice the increase in grain and lack of definition in the 16× enlargement. Kodak 2475 Recording film was used for the original negative.

Film size. Naturally, it must fit the camera being used. However, this is not as obvious as it might appear, especially if the camera is a single-lens reflex or press camera with interchangeable backs accepting a number of film sizes. The important consideration becomes the degree of enlargement desired from the negative. How large are the prints going to be? If they are extreme enlargements (16× or more) then we must use a fine-grain film plus the largest possible film size. (An enlargement of 16× means 1 in. on film will be 16 in. on the print.)

FILM

Film is sold in different ways depending on the type of equipment in which it is used.

Cartridge—for box cameras. This type offers quick, drop-in loading.

Roll film—for twin-lens, some single-lens reflex cameras, and also some press cameras.

Single packet or roll packet—for Polaroid cameras. The chemicals for development are built into the packet.

Cut, or sheet, film—for 4" × 5" or larger view cameras. This film is sold by the box and each sheet must be loaded individually.

Film loaded in cassettes—for 35mm cameras. This film is available in 20- and 36-exposure rolls and in bulk.

72

Thirty-five millimeter film is available in bulk rolls of 25, 50, and 100 ft. or longer. They can be placed in a bulk loader, which makes it less expensive to load your own cassettes. Once the bulk loader is filled with the bulk-film roll (in complete darkness) individual cassettes may be loaded in daylight. See the accompanying pictures and captions for the procedure for loading a daylight bulk loader.

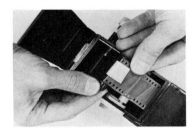

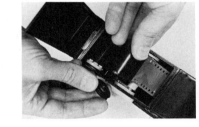

Step 1: The film is attached to the spool of the cassette, making certain that the knob of the spool is toward you and the film extends out to the right of the spool. This places the emulsion side of the film facing the spool so that when placed in the camera, it faces the aperture.

Step 2: The cover and cap are placed on the spool.

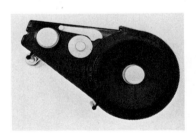

Step 3: The bulk loader is closed and the trap door is turned to the open position. This is important to avoid scratching the film as it is pulled off the large roll into the cassette.

Step 4: The counter is set for the number of exposures, plus three for leader, and that number is rolled into the cassette.

Step 5: The trap door is placed in the closed position and the door of the bulk loader is opened, the film is cut, and the cassette is removed.

Step 6: The film can be notched to make loading in the camera easier.

LOADING THE CAMERA

When loading the 35mm cassette in the camera, be certain the long knob on the cassette points down and the film points to the right toward the take-up spool. Insert the film leader in the groove of the take-up spool and make certain that the notches of the film are engaged in the film-advance sprockets of the camera. Advance the film so that the film has made one complete revolution around the take-up spool. Many photographers are disappointed to find that even though the camera film counter functioned, their film was never exposed because it was not securely attached to the take-up spool.

The camera back may now be closed. As the film is exposed and then advanced for the next exposure, watch the rewind knob on the left side of the camera. It should turn, indicating that the film is advancing out of the cassette. When the advance lever offers resistance, it means that all the film is out of the cassette. Be certain to rewind the film into the cassette before opening the camera back.

Casette film loading.

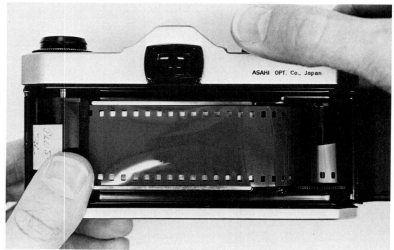

Cassette film completely exposed and rewound into the cassette. This must be done before opening the camera back.

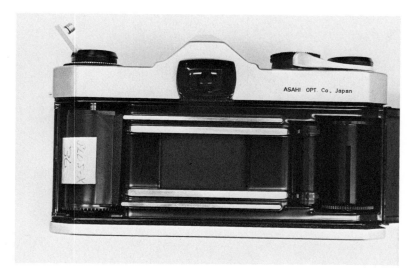

The roll-film camera is usually loaded with the unexposed roll at the bottom. The film is pulled toward the top and engaged in the take-up spool. Advance the film so that the arrow on the film's paper backing is lined up with the arrow in the camera. The camera back is now closed and the film advanced to the first picture. After all exposures have been made, continue to wind the film until no resistance is felt. The back may now be opened as the film and the backing paper have been wound tightly onto the take-up spool.

Loading sheet film is a bit more complicated as it must be loaded into sheet-film holders in complete darkness. The emulsion side of cut film can be identified by holding the film so that its notch is in the upper right-hand corner—the emulsion now faces you. Different films are notched with different notching codes so that they can be identified in the dark. The film information sheet packed with the film contains this information.

Simple sheet-film holders are loaded with one or two sheets of film at a time. The sheet is slipped into narrow guides so that the emulsion side faces out. A metal dark slide is slipped into the film holder above the film to make the compartment

Roll film loading. *Roll film completely exposed.*

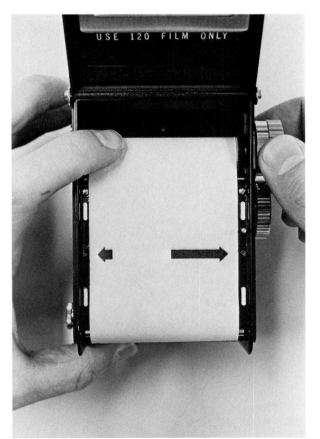

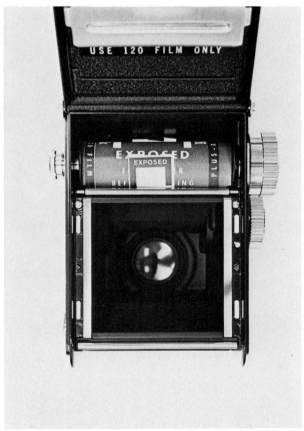

lighttight. This is repeated on the other side of the film holder. When inserting the dark slide into the holder, place the side with the raised dots out. In the light, the side with the raised dots will be silver in color. After the film is exposed, the dark slide is reversed so that the black side is out. This shows the film has been exposed. The latches on the film holder should be closed when the holder is loaded. If they are left open, it is an indication that the film holder is empty.

Left: A 4" × 5" film holder with dark slides in place. Right: A corner of a 4" × 5" film holder showing the latch locking the lower dark slide. This indicates that the lower half of the holder is loaded.

OBJECTIVES — PHASE SEVEN

1. To have some knowledge of the historical development of the latent image.
2. To identify the parts of a black-and-white film cross-section.
3. To know the difference between color sensitivity and film speed.
4. To understand the film characteristics of definition, sharpness, resolution, and graininess.
5. To list a film in each speed grouping.
6. To learn how to bulk load 35mm film.
7. To learn how to load film in all major camera types.

FOR FURTHER REFERENCE

See *Photography* by Eric de Mare (Penguin Books) for more on the history of the latent image.

See *Light and Film* by the editors of Time-Life for more on modern films.

See Kodak booklet F5, *Professional Black-and-White Films,* for a discussion of film characteristics.

DETERMINING EXPOSURE VALUE

The film has been chosen and loaded in the camera. Based on the sensitivity of the film, an exposure value must be chosen. There are several ways to arrive at the correct aperture and shutter combination that will expose the film properly. The principal four methods are:

1. Using past experience and bracketing.
2. Using the $f/16$ rule.
3. Using information from film data sheets.
4. Using light-meter readings.

Some of the above methods are reliable, while others are hit and miss affairs. Before describing them, it should be noted that black-and-white film is very forgiving when it comes to getting the correct exposure. The latitude of most black-and-white films is such that a stop or two from the correct exposure will, in most cases, still give acceptable results. This is not to say that we can be sloppy in the choice of camera settings. There is much loss of detail in prints made from negatives that are not exposed properly. Study the prints on pages 42-43 and note how the quality decreases as the aperture is opened or closed down beyond the correct exposure.

1. USING PAST EXPERIENCE

Basing an exposure on what was used in the past under similar light conditions is certainly a technique used by experienced photographers. It is, however, a doubtful technique for the beginner. If you think you know the correct exposure, but you know of no way to verify it, by all means try it. But under all such circumstances you should at least bracket your exposures. Take what you consider to be the correct exposure, then in addition, take one exposure one stop under and another exposure one stop over what you considered to be the correct exposure.

77

<center>

1/60 sec., f/8 *1/60 sec., f/5.6* *1/60 sec., f/11*

Bracketing the exposure. The first photo on the left is the exposure thought to be correct. The middle exposure is one stop over and the photo on the right is one stop under.

</center>

2. USING THE *f*/16 RULE

 The *f*/16 rule applies to pictures taken under bright-sun conditions. Reference was made to it in the construction and use of the simple kitchen camera. It simply states that for proper exposure the shutter speed is the reciprocal of the film's ASA and the aperture is *f*/16 when the subject is frontlighted by bright sun. If you are using Kodak Plus-X film, ASA 125, then the correct setting would be 1/125 sec. at *f*/16. For a sidelighted subject open the aperture one stop, and for a backlighted subject open the aperture two stops.

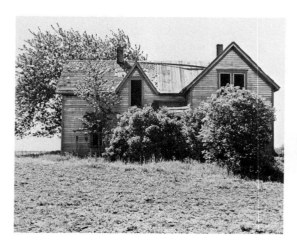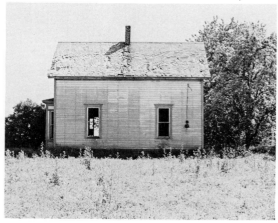

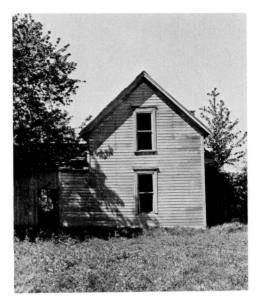

The f/16 rule with side-, back- (both shown on the opposite page), and frontlighting (left).

3. USING INFORMATION FROM FILM DATA SHEETS

Most films have a data sheet packed with them that spells out camera settings under a variety of conditions. If one reads and interprets the lighting correctly, good results should be obtained by following the instructions. The following photographs were taken using the recommended settings for Kodak Plus-X film.

Bright or hazy sun, 1/250 sec., f/11.

Heavy overcast, 1/125 sec., f/5.6.

Cloudy bright, 1/125 sec., f/8. *Open shade, 1/125 sec., f/5.6.*

Using film data sheets. Note that the bright or hazy setting of 1/250 sec. at f/11 is equal to the f/16 rule (1/125 sec. at f/16 for ASA 125).

OUTDOOR EXPOSURE GUIDE FOR AVERAGE SUBJECTS
Set Shutter at 1/100 or 1/125 sec.

Bright or Hazy Sun on Light Sand or Snow	Bright or Hazy Sun (Distinct Shadows)	Cloudy Bright (No Shadows)	Heavy Overcast	Open Shade †
f/22	f/16*	f/8	f/5.6	f/5.6

* f/8 for backlighted close-up subjects.
† Subject shaded from sun but lighted by a large area of sky.
Exposure guide from film data sheet for Kodak Plus-X film.

4. USING LIGHT-METER READINGS

Light meters are simply instruments that measure the amount of light reflected from the subject or directed toward it. Using a light meter will give you consistent results. It is the most reliable method in the determination of the exposure value.

80

Light meters are available in a great many varieties. The hand-held meter is made in two types depending on the way it is powered.

The simplest is powered by a selenium cell that converts light to energy that moves a needle to indicate the amount of light. It has no battery to wear out, but is not very sensitive to dim light.

The second type of light meter has a small battery that powers a cadmium-sulfide cell and then the needle indicator. These meters are very sensitive, and some models have no difficulty in measuring candlelight or light reflected from the moon.

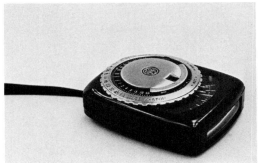

Selenium meter.

Cadmium-sulfide meter.

Meters may also be part of the camera itself. They may or may not be connected to the camera controls. In some cameras, the meter needle indicates a number that must be transferred to the lens and shutter controls. In others, the needle must be centered in a notch by adjusting the aperture or the shutter. Automatic cameras require only the adjustment of the aperture or shutter speed; the remaining setting is adjusted automatically. This last method is the trend today with the difference being whether the aperture (aperture preferred) or the shutter (shutter preferred) is set by the photographer.

Camera with built-in meter. *Camera with through-the-lens metering.*

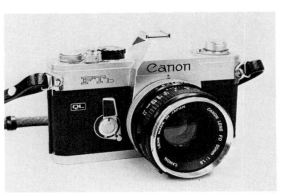

The cadmium-sulfide meter shown in the accompanying photo is operated in the following manner:

1. Set the ASA of the film being used (400 ASA in our example).
2. Point the meter at the subject. Then read the number when the needle comes to rest (15 in our example).
3. Set that number at the arrow by turning the outer ring of the meter.
4. Aperture and shutter speed combinations are now paired (1/125 sec. at f/5.6 is one of the combinations that can be used). Any pair can now be transferred to the camera.

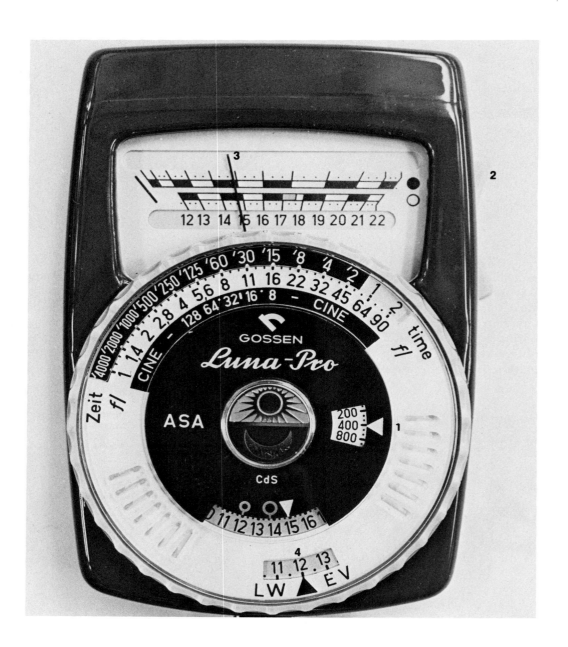

REFLECTED AND INCIDENT LIGHT

Some light meters may be used in two different ways—to read reflected light and to read incident light.

Measuring reflected light means you read the light that is reflected from the subject to the camera. When measuring reflected light, a meter's angle of reading is equal to the angle of acceptance of a normal lens—about 50 degrees.

Measuring incident light means you read the light that falls upon the subject. The angle of acceptance must therefore be much wider than the reflected reading. The angle of acceptance of a meter measuring incident light is about 180 degrees. A light-gathering dome collects the light and brings it to the sensor.

Light-gathering dome in position for measuring incident light.

Light-gathering dome should not cover the sensor when measuring reflected light.

Far left: This photograph was made using the reflected method. The exposure is satisfactory. Left: A satisfactory exposure was also made by using the incident method.

Under normal conditions, either an incident reading or a reflected reading may be used. The advantage of using one over the other is realized when special light conditions exist. This often happens when large expanses of light areas surround a dark subject.

The light sky in the photograph at right gave the reflected reading an exposure setting that did not admit enough light to properly record the detail of the building.

By moving to the position of the buildings and facing the light source to take an incident reading, a proper exposure can be obtained to record the detail in the building.

An incident reading is also valuable in correctly exposing a subject when it is backlighted. The photograph on the left shows the result of a reflected reading when the light is coming from behind the subject. The photo on the right shows the result of an exposure made by an incident-light reading.

Often it is impossible to step in front of the subject to make an incident reading. In that case, a combination of a reflected reading and the *f*/16 rule (opening the aperture two stops for backlighted subjects) would give an adequate reading. It is also possible to take a reflected reading from a nearby subject that is in the same light and has the same reflectance as the subject. A reading from the back of a person's hand is often useful in determining the correct exposure for a subject whose face is far away. (See also pages 125-126.)

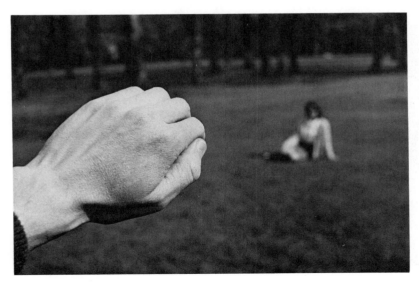

Using a reflected reading from the back of your hand to determine the correct exposure for a distant subject.

85

Cameras with built-in light meters utilize a number of different light reading systems—all of them based on reflected light. Some of these systems read the whole picture area and give an average exposure based on the entire scene. Others use a center-weighted system in which the central part of the picture area is read to determine about 70 percent of the exposure and the background the remaining 30 percent. Still others have a spot meter that reads only a very small portion of the picture area. Some cameras incorporate two of these systems into one meter, permitting the user to choose the system best suited for the situation.

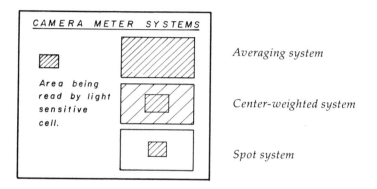

The spot meter found on some cameras can also be purchased in a separate hand-held meter. It has a very limited reading angle, as low as one degree. It is extremely useful for correct exposures of subjects that are totally surrounded by a dark background, especially when it is impossible to approach the subject closely.

Spot meters are ideal for reading scenes like this.

READING A SCENE FOR HIGHLIGHT AND SHADOW

Exposure readings must be made carefully. The principal reason lies in the great difference in the amount of light reflected from lighter areas of a scene as compared to reflectance of dark areas. The difference between highlight areas and areas of shadow in a bright sunlight scene may be 200 to 1, or higher. That is, the highlight areas are approximately 200 times brighter than the shadow areas. This great difference between highlight and shadow areas is called the contrast of the scene.

Modern films are able to record a contrast range of 200 to 1. Most printing papers, however, will not produce as great a contrast. Glossy papers reproduce a greater range than matte, or dull sheen, papers.

It is necessary in the determination of exposure value to consider what part of a scene the photographer wishes to record and retain in the final photograph. If an exposure is great enough to record detail in a shadow area, it may mean a certain loss of any detail in a highlight area. Remember that a highlight, or white area, in a scene will be recorded on the film as a dark area. This is due to the silver deposit formed where the emulsion is exposed to much light. This area of the negative will print very light in the enlarging process because the density of the silver deposit will not let much light pass through the negative to the paper. Conversely, shadow areas will reflect little light and will be recorded on the negative as very light silver deposits (or none at all) and in printing will pass much light to form dark areas on the printing paper. To record a shadow-area detail requires more exposure and to record a highlight-area detail requires less exposure.

Needless to say, only one exposure can be made, so it is imperative to choose the exposure that will record the detail the photographer wants. The latitude of the film allows us to choose our exposure according to what we wish to record. Generally, we should expose film with the least exposure required to give the detail we desire in the dark areas. Any exposure greater than this minimum will block detail in highlight areas.

1. *Highlight areas*
2. *Shadow areas*

Left: This photograph of the Oregon Coast was printed using a negative that had been exposed for shadow detail, yet the film was able to hold detail in the highlight areas. Exposure for highlights normally requires less exposure. Right: Here the exposure was long enough to record detail in the shadow area, but the long exposure has blocked up most detail in the highlight area. Exposing for shadow detail requires a longer exposure.

FILTER FACTORS AND EXPOSURE

Filters are among the elements that influence what is recorded on the film.

CONTRAST FILTERS

Contrast filters are made in a variety of colors that subtract some of the rays of light reflected from a scene and thereby cause a change in the density of those areas in the negative. For example, a yellow filter absorbs, or subtracts, blue light from a scene. This will cause a blue sky to appear darker. Having lost some of the rays to the absorbing filter, the negative will be less dense in that area and consequently the print will be darker in that area.

A filter transmits its own color and absorbs what is left. As all natural colors are made up of red, green, and blue, a red filter will transmit red and absorb green and blue. It is helpful, then, to know what colors will be absorbed by various filters.

Color of filter	Color absorbed
Yellow	Blue
Red	Blue and green
Blue	Red and green
Magenta	Green
Cyan	Red

Colors in a scene will be darker if they are absorbed and lighter if they are transmitted. If you wish to make red roses lighter, then use a red filter.

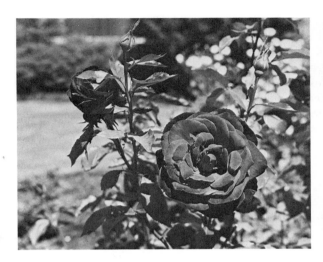
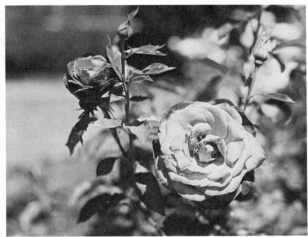

Left: The rose appears dark when no filter is used. Right: With a red filter, the rose appears lighter.

Three of the most popular filters for use with black-and-white film are the No. 8 (light yellow), the No. 15 (dark yellow), and the No. 25 (red). The four accompanying photographs illustrate the absorption rate of the blue in the sky as the darker filters are used.

Far left: No filter. Left: No. 8 (light yellow) filter. Below left: No. 15 (dark yellow) filter. Below right: No. 25 (red) filter.

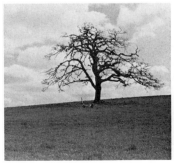
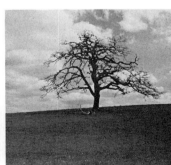

It is important to note when using filters that the subtraction of light rays of a certain color will cause the film to receive less light. Exposure must be adjusted accordingly, either in terms of increased time or a larger lens opening.

Packed with most filters are instruction sheets that give the filter factor for that particular filter. The normal exposure without the filter must be multiplied by the filter factor to obtain the correct exposure when using the filter. A filter factor of 2 will mean doubling the exposure time or opening the lens one stop. If the correct exposure is 1/125 sec. at f/16, we would make the following aperture adjustments:

TABLE OF FILTER FACTORS *

Filter	Factor	Aperture adjustment
UV or Haze	1	none (f/16)
No. 8 (light yellow)	2	f/11
No. 15 (dark yellow)	2.5	between f/8 and f/11
No. 11 (green)	4	f/8
No. 25 (red)	8	f/5.6
Polarizing	2.5	between f/8 and f/11

Filter factors may vary with different films.

The UV and haze filters are often used to cut the bluish haze that often exists in landscapes and other distant scenes. Note that they do not require any increase in exposure. No. 8 (light yellow), 15 (dark yellow), and 25 (red) filters will also help in cutting haze.

Cameras with behind-the-lens meter systems read the amount of light coming through the lens, so any filters added to the lens do not create a need for exposure adjustment.

Left: This picture of Athens, Greece, was made without a filter. The one on the right was taken with a UV filter.

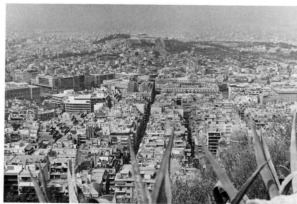

NEUTRAL DENSITY FILTERS

Neutral density filters are used to cut the amount of light entering the camera lens without changing the contrast of the scene. They are especially useful when photographing in bright light with high-speed film when there is a need to use full aperture to limit depth of field. Neutral density filters come in various densities. A density of 0.30 means that exposure is reduced by one f/stop. A density of 0.60 reduces exposure by two stops. Neutral density filters would also allow you to use slower shutter speeds to purposely blur action.

Neutral density filters reduce the amount of light entering the camera.

CROSS-SCREEN FILTERS

Cross-screen filters are special purpose filters that produce dramatic cross-shaped highlights on surfaces reflecting bright rays of light. Their use is limited, but under certain conditions cross-screen filters add flair to a photograph.

Cross-screen or star filters add flair.

91

POLARIZING FILTERS

Polarizing filters act in just the opposite way to cross-screen filters. They reduce reflection and glare. They may also be used to add contrast and reduce haze in much the same way as do contrast filters.

Polarizing filters remove polarized light—reflected light traveling in only one plane—from the scene. This is done by rotating a screen within the filter until the darkening effect desired is achieved. The filter factor for a polarizing filter is 2.5. A common use of the polarizing filter is to reduce window reflections.

Window reflections are reduced with the polarizing filter.

No filter. *With polarizer.*

OBJECTIVES—PHASE EIGHT

1. To know four different methods of determining exposure value.
2. To learn how to set, read, and use a light meter.
3. To know how to read both incident and reflected light.
4. To learn how to expose for highlight and shadow.
5. To understand the use of contrast, neutral density, cross-screen, and polarizing filters.

FOR FURTHER REFERENCE

See *Light and Film* by the editors of Time-Life for information on exposure and filters.

See Kodak booklet AB-1, *Filters for Black-and-White and Color Pictures,* for one of the best concise discussions of filters available.

ADDING LIGHT

Although many high-speed films are on the market today, especially ultra-sensitive ones like Kodak's 2475 Recording film which can be exposed at ASA 4000, extreme low-light photography still has severe restrictions even when using these films. The films will not give fine-grain enlargements, nor do they give adequate resolution. They are special purpose films and are not intended for normal photographic applications. The answer to the problems of low-light photography is normally the addition of light rather than the use of more sensitive materials. Added light may be divided into two classifications, continuous light and discontinuous light.

CONTINUOUS LIGHT

Most often, continuous light is used indoors where the photographer has complete control over it. Continuous light makes use of a variety of lamps and lighting equipment that may be manipulated in such a manner as to provide the photographer with just the right light, in the right places, to portray the subject as the photographer sees fit. Continuous lighting is most often used in product photography and in portraiture. The most important controls offered to the photographer when using continuous lighting are:

1. The number of lights used and the power of these lamps.
2. The position of these lights in relation to the subject and in relation to each other.

Effective photography can be done with only one light, and the easiest way to learn lighting is to work with only one light and vary its position and distance in relation to the subject. One light can provide many different forms of illumination.

THE POSITIONS OF A SINGLE LIGHT

Try the following lighting situations and study the effect.
1. Frontlighting of a three-dimensional subject is flat and shadowless, giving the effect of a flat object.

93

2. Sidelighting may take two forms; normally a light is positioned 45 degrees to the side of the subject. When positioned 90 degrees to the side, sidelighting is known as crosslighting. Of these two, crosslighting is the most harsh, dividing the subject into a dark-shadowed half and a bright half near the light. Sidelighting makes a subject three dimensional by casting shadows that make features stand out. Sidelighting is useful in giving a subject volume. Crosslighting is especially effective in showing texture.

3. Lighting from the top gives much the same effect as does sidelighting. But when used alone, it produces a not-too-pleasing effect as it is not a natural form of lighting.

4. Placing a light under the subject, by using a glass plane or some other support for the subject, is another unnatural form of lighting. It gives a special eerie effect.

5. Backlighting rims the subject in light and is useful for silhouettes. With only one light used behind the subject, it is not possible to expose for detail on the front of the subject, thus only a silhouette can be obtained.

6. Soft lighting can be effective for certain subjects. By directing a light onto a surface near the subject and bouncing this back to the subject, one can obtain a diffuse-lighting effect, which will be more natural looking than a light pointed directly toward the subject.

The photographs below and on the next page illustrate the effects various positions of a single light have on a subject. In all cases, exposure value was determined by taking a reflected-light meter reading. Lighting for such an experiment need not be elaborate—an ordinary 150-watt household bulb was used in a reflector. One may purchase reflector floods that have their own built-in reflector. Most of these, however, are 250- to 500-watt bulbs and are too powerful for this type of controlled lighting.

Frontlighting. *45-degree sidelighting.* *90-degree sidelighting.*

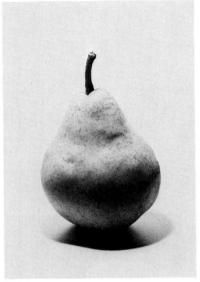 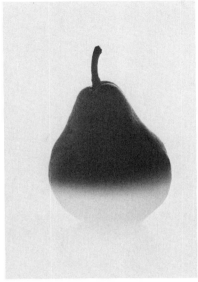 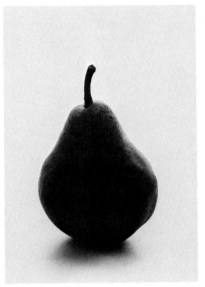

Toplighting. *Bottom lighting.* *Backlighting.*

USING MORE THAN ONE LIGHT

Proper placement of lights becomes even more important with the use of more than one light. In portrait work, three lights are normally used—five for a completely natural effect. These five lights are:

1. The key light. This is the main light. It has the most power and is usually placed to the right of the camera, which is in front of the subject.
2. The fill light. The key is so powerful that it causes severe shadows, which are filled in to a degree by the fill light. This light must not be as powerful as the key light, or it will cast shadows of its own. It is usually placed to the left of the camera.
3. The accent or rim light. This light is placed where needed to high-light a particular part of the subject, such as the hair, for emphasis.
4. The background light. This light is aimed at the background to separate it from the subject. It is placed in back of, or to one side of, the subject.
5. The bounce light. Bounce lighting is reflecting a light from any reflective surface onto the subject. It is softer than direct lighting. Light-colored walls or large pieces of board may be used to reflect this light. Professional photographers will often use a reflective umbrella for this purpose. A bounce light can be used as a main or fill light.

95

Normal light placement for portrait work.

Above left: Key light only. Above right: Key and fill lights. Below left: Key, fill, and accent lights.
Below right: Key, fill, accent, and background lights.

DISCONTINUOUS LIGHT

The other principal means of adding light is by flash, either bulb or electronic.

FLASHBULBS

The last forty years have seen great advances in the manufacture of flash equipment. Until the invention of electric photoflash bulbs in 1929, most artificial lighting was done with magnesium flash powder, which was spread into a long narrow pan, held overhead, and lighted by a powder cap. It was an uncertain, dangerous, and smokey method of adding light. So much so that photographers often had firemen as assistants.

Conventional flashbulbs used today contain a wire filament covered with an explosive primer paste surrounded with aluminum or zirconium wire foil. The filament and wire filling are set off with an electrical current, or on the newer bulbs through mechanical means. The burning of the metal gives a short intense flash. This flash may reach a peak rather quickly as in the case of medium-peak bulbs (M) or much more slowly as in the case of slow-peak bulbs (S). Flat-peak or focal-plane bulbs (FP) hold their peak for a longer period of time and are used on cameras with focal-plane shutters. Because of their long duration, they allow the shutter to move across the film and expose it properly.

In using flashbulbs, it is important to note the proper aperture and shutter settings for the particular combination of film and bulb being used. Bulbs are rated according to their light output, and camera settings must be adjusted accordingly. An M2 bulb produces approximately 7000 lumen seconds of light while a No. 5 bulb produces about 20,000 lumen seconds. Subject distance also becomes a factor in determining proper exposure. Guide numbers are provided with the bulbs for various films. The aperture is determined by dividing the flash-to-subject distance into this guide number.

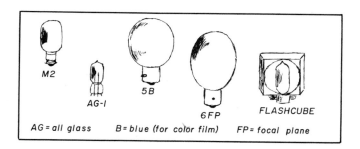

Conventional flashbulbs.

ELECTRONIC FLASH

The greatest advancement in the field of added light has been in the development of the electronic lamp. It was first designed by Harold Edgerton of the Massachusetts Institute of Technology in 1931. Basically, an electrical charge is held in storage capacitors, which when released will flash through a gas-filled tube. A

reflector behind the tube throws the light toward the subject. The duration of the flash is very short, usually between 1/500 sec. and 1/2000 sec. The gas-filled tube will produce about 10,000 flashes in its lifetime. Batteries usually supply the initial electrical charge to the storage capacitors, but some units will operate from 110-volt household current. Batteries may be recharged in some units.

Manufacturers of electronic flash units usually furnish a guide number for the kinds of films being used. The guide number will depend on the light output of the flash unit. Normally, a shutter speed is chosen and the aperture is determined by dividing the flash-to-subject distance into the guide number. If the guide number is 40 and the flash-to-subject distance is 10 ft., then the *f*/number is 4. On many flash units, a dial is set at the ASA of the film. Then one may find the flash-to-subject distance on the scale, and directly across from it the aperture setting.

Honeywell Model 700 electronic flash unit.

Below left: Proper aperture may be determined on this electronic flash unit by setting the film's ASA (125) at the triangle, determining the flash-to-subject distance (20 ft.) on the outside scale, and reading the f/number opposite this distance (f/8). Below right: On automatic flash units, the ASA (125) is set at the triangle, and the aperture (f/8) is then read and set on the camera. No adjustment is needed for changing shooting distances.

Many of the electronic flash units introduced in the past few years automatically compensate for various flash-to-subject distances. These automatic units release only the amount of light needed to properly expose the film being used. Sensors on the front of the flash unit read the light bouncing back from the subject area and compute the exact amount needed. If the full output of the unit is not needed, the remaining power is either burned off inside the flash or is stored to be used later.

The automatic units have a dial on which the film's ASA may be set. Shutter speed is set at the fastest speed that can be synchronized with the flash, and the aperture, read from the dial, remains the same under *all* flash-to-subject distances. The unit will automatically compensate for changing distances. Many of these units will also operate manually, meaning you determine the aperture based on subject distance. When used manually, make certain that the switch is set in the manual position. When using bounce flash, most units must be set in the manual position or the unit will read the light from the ceiling or umbrella and not the subject, and exposure will not be correct. Bounce flash requires approximately two additional *f*/stops of light.

f/2.8

f/4

f/5.6

f/8

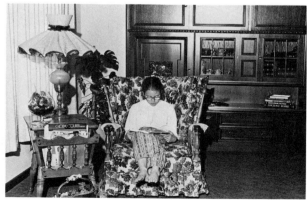

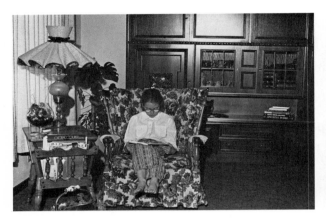

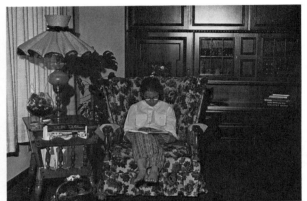

f/11 f/16

DETERMINATION OF GUIDE NUMBERS

Guide numbers have been established for most flashbulbs and electronic flash units. However, it is a good idea to establish your own guide numbers for the particular combination of film and equipment that you are using. By doing so, you will know precisely where you stand in relation to correct exposure when using discontinuous light. To establish a film's guide number, take a series of photographs at the flash-to-subject distance of 10 ft., going through each aperture setting of your camera. Print these pictures using the same exposure for all of them. Choose the one you feel is the best exposure, multiply the aperture used for that particular exposure by 10 (the distance you were from the subject), and you have established the guide number for your particular combination of film and equipment. In the examples, the exposure made at $f/8$ is the best. By multiplying $f/8 \times 10$, we have computed a guide number of 80 for this particular film and flash.

1/60 sec. *1/125 sec.*

1/250 sec. *1/500 sec.*

These photographs were taken with a camera with a focal-plane shutter. With this camera, speeds above 1/60 sec. may not be used with electronic flash. If higher speeds are used, only part of the picture is exposed to the light.

SYNCHRONIZATION

Both flashbulbs and electronic flash give off a very brief period of light. The period of time for a flashbulb is about 1/25 sec. The duration for an electronic flash unit is much shorter, about 1/500 sec. to 1/2000 sec. or less. Because of this short time period, it is necessary to make certain the shutter of the camera is open when the flash actually fires. This is called synchronization of flash with shutter. Most leaf shutters are synchronized at all shutter speeds. It is the focal-plane shutter that cannot be synchronized easily. If the focal-plane shutter moves across the film with a narrow opening (from a fast shutter-speed setting) the flash duration may not be long enough to illuminate the scene while the shutter travels across the film. If you think of the focal-plane shutter as a window moving across the film, it is easy to understand that the window may be exposing the left-hand part of the film when the flash peaks. That would mean that the right-hand section of the film would not receive the benefit of the light.

USING FLASH

The great majority of flash photographs are taken with the flash mounted on the camera. This is the easiest method of using flash, but it often produces the worst results. This picture is flat, and the straight-on lighting is harsh.

101

Left: To a certain degree, this harshness can be reduced by diffusing the light. This can be done by placing a white cloth or handkerchief over the flash unit and opening the aperture one stop. Center: A better three-dimensional effect can be achieved by removing the flash from the camera and holding it above the camera and slightly to the right. This gives a modeling effect, creates depth, and makes the subject more true to life. Right: If a much softer effect is desired, bounce the flash off the ceiling or a nearby wall. Normally, the aperture should be opened two stops to compensate for the loss of light. Many professional photographers use a photographic umbrella for bouncing light.

USING FILL-IN FLASH

When taking pictures with available light, it is easy to expose for the overall area and lose the detail in the subject's face—especially if the face is in a shadow. This type of situation is a good place to add fill-in flash with a flashbulb or electronic flash unit. The flash will lighten the shadows on your subject's face, give you better facial expressions, and help to separate the subject from the background.

Right: Available light only. Far right: Available light plus fill-in light. The light-meter reading was 1/60 sec. at f/16. The guide number for the film and flash used was 160. Dividing the aperture of f/16 into 160 gives a flash distance of 10 ft. The flash was moved to 14 ft. to retain some of the shadow.

102

The easiest way to determine exposure for fill-in flash is to determine the overall exposure with a light meter. Then find the guide number for that particular combination of film and flash you are using. Divide the aperture into the guide number, and that gives you the distance the flash unit should be from the subject to balance the available light. If you wish to retain some shadow, and thereby a modeling effect, you must increase the available light-to-flash ratio by moving the flash further from the subject.

Multiple-image exposure.

Example of the multiple-exposure technique.

USING FLASH AND MULTIPLE EXPOSURE

Electronic flash can be used to make multiple exposures on a single frame of film. To make such a photograph, choose a dark room with a black or very dark background. Have the subject take the first position, open the shutter (and keep it open), and fire the flash. Now fire the flash again as soon as the subject takes the second position. Repeat this for each position you want in the final photograph and

103

then close the shutter. Exposures should be normal. Variations of this technique can be made by adding a spotlight from the side. As the subject moves to the next position, the image is recorded as a blurred motion on the film. The spotlight cannot be too close nor too strong, or the image will be overexposed. The actual shooting must be done quickly to avoid overexposure from any existing light in the room.

OBJECTIVES—PHASE NINE

1. To learn how to achieve various lighting effects with one light.
2. To learn the correct placement of different lights for effective portraiture.
3. To learn how to expose film properly using flashbulbs and electronic flash.
4. To determine the guide number for a film and flash combination.
5. To understand the use of flash to achieve a modeling effect.
6. To learn how to use flash as a fill light.
7. To learn the use of flash creatively through multiple imagery.

FOR FURTHER REFERENCE

See Robert B. Rhode's book *Introduction to Photography* (Macmillan) for material on lighting with flood and flash. Chapter 9.

See Kodak's *The Here's How Book of Photography* for more on fill-in flash and multiple imagery.

MOVING IN CLOSE

While there is little agreement as to the exact definitions of the terms close-up photography, photomacrography, and photomicrography, there is agreement that all of these photographic processes require moving in closer to the subject than the camera focusing system will normally allow.

Moving in close immediately necessitates a discussion of film image size and subject size. This relationship of image size to subject size is always written with the image size first and the subject size second. A ratio of 1:2 would mean that the image size is one half the subject size, or one half life size.

Close-up photography is generally thought to cover ratios of 1:20 to 1:1 (1/20th life size to life size). Photomacrography covers ratios of 1:1 to 20:1 (life size to twenty times life size). Photomicrography covers ratios from 20:1 to 1000:1, and is done with the aid of a microscope. Macrophotography means the same thing as photomacrography, but microphotography, which is the making of small photographs such as microfilms where much information is placed on a very small film area, should not be confused with photomicrography.

In this phase, we are concerned with close-up photography. Close-up photography requires the use of supplementary lenses, which are added to the normal lens of the camera, or the use of extension tubes or bellows, which are placed between the lens and the camera body to extend the focal length of the lens. Extending the focal length of the lens will cause the subject to be projected as a larger image on the film. Earlier we saw that changing from a short focal-length camera to a longer focal-length camera gave a larger image size.

Moving in close can be exciting. With close-up photography, we are able to look at the detail of a subject in a way that we often overlook when we see the subject as a whole surrounded by other objects that compete for our attention. Close-up photography is accomplished in one of four ways:

1. By using supplementary lenses.
2. By using extension tubes.
3. By using a bellows.
4. By using a macro lens.

USING SUPPLEMENTARY LENSES

Supplementary lenses, or close-up lenses, are normally sold in three designations, + 1, + 2, and + 3. This number indicates the strength or power of the lens. 105

A + 2 lens will bring the subject closer than a + 1 lens. It is possible to combine several of these lenses to get even closer, but the quality of the photograph will suffer if too many are placed together, because the aberrations (defects) of so many pieces of optical glass start to add up.

The principal advantage of the close-up lens is the ease with which it may be used, especially on cameras without a through-the-lens metering system. No exposure compensation is necessary when using supplementary lenses. When using a close-up lens, it is always good policy to stop down the lens to $f/11$ or $f/16$ for increased depth of field.

If the camera you are using does not have a through-the-lens viewing system, then you must make certain you correct for parallax error and measure the point of focus. If you do not do this, you will find the top missing from your photo and unsharp images. You can correct for parallax by tipping the camera slightly in the direction of the viewfinder, and a wire frame can aid in focusing.

Using a + 1 with a normal lens.

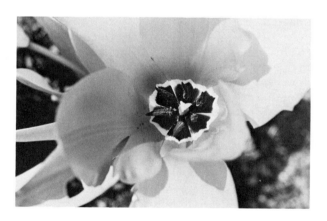

Using a + 2 with a normal lens.

Using a + 3 with a normal lens.

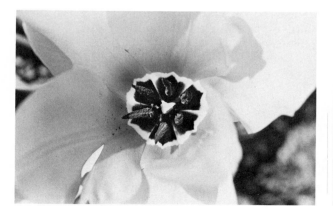

A set of close-up lenses that are screwed onto the front of the camera lens.

USING EXTENSION TUBES

Another means of close focusing is through the use of extension tubes. They are available in sets of three or four separate rings of different lengths that are mounted between the lens and the camera body. They can be used singly or in combinations of the various lengths to achieve the image size desired. Generally, extension tubes are less costly than supplementary lenses.

Extension tubes are not as easy to use as are supplementary lenses. Exposure compensation is necessary, since the focal length has been increased and the light has a longer distance to travel to the film plane. When a long focal-length lens is constructed, the necessary increase in exposure is built into the lens. That is, the relationship of aperture to focal length in an *f*/3.5 50mm lens is the same as in an *f*/3.5 200mm lens. When you add extension tubes, you do not increase the maximum aperture of the lens to compensate for the increase in focal length. Because of this, you must calculate a new exposure. This can be done by following the procedure below:

1. Measure the focal distance from the lens to the film plane.
2. Divide the focal length of the lens into this distance.
3. Square the answer from step 2.
4. Take a meter reading and choose the aperture you wish to use. Note the shutter speed.
5. Multiply the shutter speed by the answer from step 3. This becomes the shutter speed you use.

Example:
1. The focal distance is 100mm.
2. The focal length of the lens is 50mm which divided into 100mm is 2.
3. The 2 squared is 4.
4. The meter reading is 1/125 sec. at *f*/16.
5. Multiply 1/125 by 4 = 1/30. My setting is 1/30 sec. at *f*/16 for the correct exposure.

These calculations are not necessary if your camera is equipped with a through-the-lens metering system.

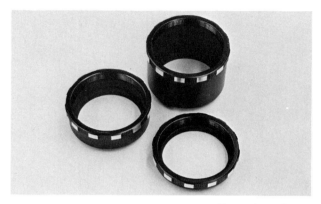
Extension tubes.

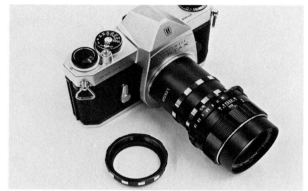
Extension tubes mounted on a camera.

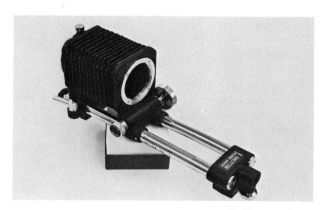
Bellows unit.

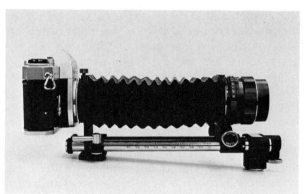
Bellows unit mounted on a camera.

USING THE BELLOWS

The bellows is used in the same way that extension tubes are used. It is mounted between the lens and the camera body and used for extreme close-ups. Bellows units give ratios of 1:1 to 3:1 depending on the focal length of the lens used. Exposure time must be calculated in the same way as with the tubes unless you have a through-the-lens meter. However, many bellows units will indicate exposure factors for various magnifications.

These two photographs were taken using a bellows at 3:1 magnification ratio then enlarged to the size shown here. The photograph above is a small area of white bread. The lower one is a section of Washington's face on a one dollar bill. Film used was Kodak High Contrast Copy.

USING A MACRO LENS

Some manufacturers produce lenses that will focus from life size (1:1) to infinity without any attachments. They are usually referred to as macro lenses. They can be used for general photography, but a lens that has little aberration at 1:1 may be poorly corrected at infinity. It is best to use these lenses for their intended purpose—close-up photography. Using the macro lens for close-up work is convenient and fast. Exposure is normally determined by using the exposure factors on the lens that correlate with the degree of magnification.

OBJECTIVES—PHASE TEN

1. To understand magnification ratios as they relate to close-up photography.
2. To learn how to use supplementary lenses, extension tubes, bellows units, and macro lenses.
3. To compute correct exposures for extension tubes, bellows units, and macro lenses.

FOR FURTHER REFERENCE

See Kodak's technical publication N12A, *Close-Up Photography,* for an excellent introduction to the possibilities of this photographic area.

For material on more extreme magnification see Kodak booklet N12B, *Photomacrography.*

Otto R. Croy's book *Creative Photomicrography* (available through Amphoto) gives an artistic touch to this field. See Phase Seventeen in this book for related material.

THE NEGATIVE

PART THREE

FILM PROCESSING

After the film is correctly exposed, the next technical step in black-and-white photography is the processing of the film. This is not at all difficult; however, if you want consistently good results you must be consistent in method.

EQUIPMENT FOR FILM PROCESSING

Before we can discuss method, we must discuss equipment. In addition to some type of timer, preferably calibrated in minutes and seconds, a thermometer, a 16 ounce graduate for mixing chemicals, a funnel, and three brown bottles for chemicals, you will need a developing tank for the film size you have exposed. Four types of lighttight tanks are shown below:

Left: Stainless steel daylight-type tank, which may be inverted during processing. It uses a stainless steel reel that is somewhat difficult to load at first. Different size reels are used for different size films. Center: Kodak plastic tank, which uses a plastic film apron, is very easy to load. The tank cannot be inverted during processing. Different apron sizes are available for different size films. Right: Yankee plastic tank with adjustable reel for 35mm and roll film. Although easy to load, this tank cannot be inverted during processing.

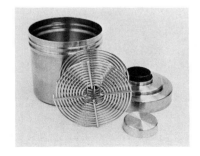
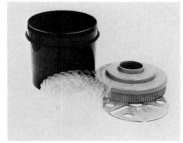
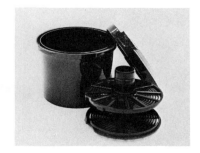

The Yankee daylight tank for 4" × 5" sheet film.

Film may be developed in enlarging trays, but the total development process must then be carried out in complete darkness. The tanks pictured here are all daylight tanks, meaning that they may be used in normal light after loading is completed in the dark.

LOADING FILM

It is a wise idea to become very familiar with the way your tank is loaded before you attempt to load it with important film in the dark. Loading the stainless steel reel will take the most practice.

Remove the film from the cassette by either prying or snapping off the cap from the cassette body, or by unscrewing the cap in the case of plastic cassettes. The film, wound on the spool, may then be pulled from the cassette. Care should be taken not to touch the flat surfaces of the film. Clip the film so that the end is square. With the reel in the left hand, feed the cupped film with the right hand into the center of the reel. The open spiral of the reel end should face the right hand. Rotate the reel with the left hand and gently feed the film onto the reel. If the film jumps out of the correct spiral, back up and start again. The film will not develop properly if there are two rotations of film in one spiral.

Remove film from cassette. *Start film on reel.* *Feed film onto reel.*

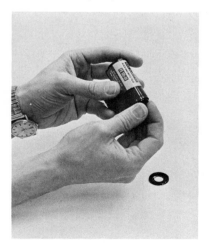
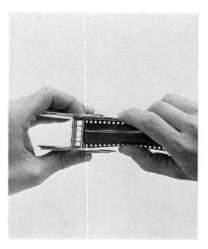
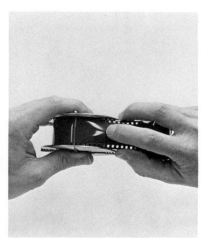

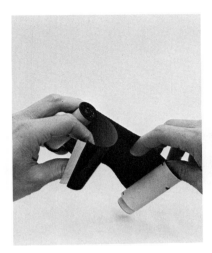
Remove paper backing.

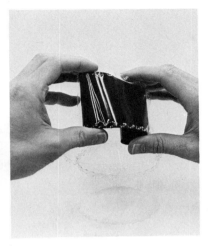
Roll the film with the apron.

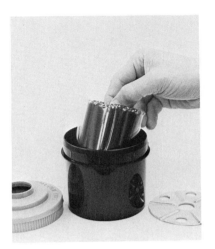
Insert film and apron in tank.

When loading roll film, the paper backing must first be removed. Loading procedures are then the same for the stainless steel reels. For the plastic Kodak tanks, the long plastic film apron is first unrolled, then the film, less the paper backing, is inserted in the center of the plastic apron. The two are then rolled, not too tightly, into a single roll and placed in the developing tank. Be certain to replace the lid before the lights are turned on.

The sides of the Yankee reel may be pulled apart or pushed together to fit the film's width. Loading the Yankee tank is a matter of starting the film on the outside spiral, holding onto each side of the reel with each hand, and rotating hands in opposing directions as you put pressure on the edges of the film. The film then feeds itself toward the center of the reel. It may be helpful to clip the corners of the film before starting to load so that the film does not catch the edges of the reel.

Loading sheet film into the hangers is a simple matter of removing it from the sheet film-holder and slipping it into the hangers.

Remove film from hanger.

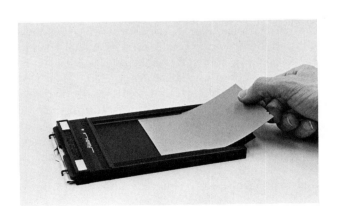

115

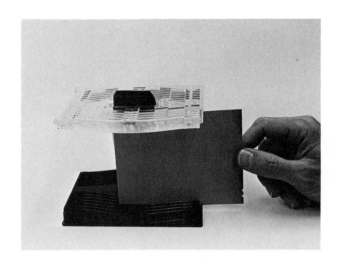

Insert film on rack.

FILM PROCESSING CHEMICALS

The chemicals used in the development of film perform three essential operations. The developer is the agent that changes the exposed silver halides in the film's emulsion into metallic silver to form the visible image. The stop bath is the agent that stops the developing action, and the fixer dissolves the unexposed and undeveloped silver halides so that further exposure to light will have no effect on the film. Washing then removes the fixer.

There are many developers on the market. The choice should be based on the type of film used and the results desired. If a slow, fine-grain film is used, then it is wise to match it with a fine-grain developer. It is good to choose one developer and work with it for a while until you become familiar with its characteristics. When you become experienced, you should try others. Two developers that are considered all around developers are Kodak D-76 and Agfa Rodinal. D-76 is available in powder form and is mixed with water. Rodinal is a concentrated liquid form that must be diluted to various ratios for different films. Both are medium- to fine-grain developers and produce excellent results.

When development is completed, the film is rinsed in a 1–2 percent solution of acetic acid. This stops the development process. Acetic acid normally comes in a 28 percent solution that must be diluted before use. Use 6 ounces of 28 percent acetic acid with 1 gallon of water for a working solution. Acetic acid is also available in a much more concentrated solution known as glacial acetic acid. Treat this with respect, as it can cause painful burns. To make a 28 percent solution, mix 3 parts of glacial acetic acid with 8 parts of water. Then a working solution may be diluted from that.

The fixing bath dissolves the unexposed and undeveloped silver halides. This solution is often referred to as the hypo solution. It is available in powder or liquid form. As some fixing solutions work more rapidly than others, the directions with the chemical should be followed to determine the time the film should be in the fixing bath.

It is essential that all chemicals and water rinses be adjusted to a temperature of 68 degrees F. Consistent results will be obtained if this is done. Some common Kodak film developers are:

D-19 for high-contrast negatives
DK-50 general-purpose developer
HC-110 for rapid processing of films
D-76 all-purpose developer
Microdol-X fine-grain developer

FILM PROCESSING PROCEDURES

The steps for processing black-and-white film, once the tank is loaded, are:

1. Adjust the tap water to 68 degrees F., fill the tank with water, agitate briefly, and empty. This removes dyes used in some films and wets the film so that it takes the developer more evenly.
2. Check temperatures, start the clock or note the time, and pour in the developer (diluted if necessary). Use 8 ounces of solution for a single 35mm reel and 16 ounces for roll film. Agitate briefly every 30 seconds. Do not agitate the same way every time. Invert the tank, or tip it if it cannot be inverted, and then move it back and forth the next time. Do not establish a pattern that would move the same solution over the same film area every time you agitate the tank. Empty the tank when the time has expired.
3. Fill the tank and rinse for 30 seconds in a diluted acetic acid stop-bath solution. If not available, use water. Empty the tank.
4. Fill the tank with fixer. Agitate periodically. Empty the tank at end of recommended time. The film may be exposed to light at this point.
5. Rinse with water for 30 seconds.
6. To reduce washing time and conserve water, treat in a hypo clearing agent solution for 2 minutes. Agitate during this time.
7. Wash in water (68 degrees F.) for 5 minutes. If you have not used a hypo clearing agent, wash for 30 minutes in running water.
8. Treat the washed film in a wetting agent, such as Kodak's Photo-Flo solution. This solution will reduce drying marks; follow instructions carefully. Hang film and let dry.

DEVELOPING TIMES FOR D-76 AT 68 DEGREES F.

Film	Not diluted (minutes)	Diluted 1:1 (minutes)
Panatomic-X	7	9
Verichrome Pan	7	9
Plus-X Pan	5½	7
Tri-X Pan	8	11

117

NEGATIVE CARE AND STORAGE

The negative should be allowed to dry in a dust-free place. The emulsion can be easily scratched if it is not allowed to dry completely.

Some type of storage system should be devised for negatives. A good system uses transparent, glassine pages that have sleeves built in for the various film sizes. This allows inspection of the negatives without removal and consequent handling. The pages can be numbered and dated and a system of index cards made to provide easy access to the proper negative. This may not sound important at first, but as your photography grows, you will find it convenient to have easy access to your negatives.

Negatives may be cleaned if necessary. A very soft cloth dipped in alcohol may be used on the film-base side of the negative. Cleaning the emulsion side usually leads to trouble and should be avoided. Always handle negatives by the edges to avoid leaving fingerprints on them.

OBJECTIVES — PHASE ELEVEN

1. To learn how to develop black-and-white film properly.

FOR FURTHER REFERENCE

See *The Print* by the editors of Time-Life for basic film processing procedures.

See Kodak booklet AJ2, *Basic Developing, Printing, Enlarging,* for a concise statement on the developing process.

Ernest Satow gives a more technical discussion of the chemicals used in film development in his *35mm Negs and Prints* (Amphoto).

For a handy darkroom guide see the Kodak *Darkroom Dataguide.*

NEGATIVE APPRAISAL

After your negatives have properly dried, you will have your first opportunity to really examine the results of proper film choice, proper exposure, and consistent processing procedures. The real advantage in the use of consistent processing procedures lies in the opportunity to study the results of a variety of exposure values. As you look at your negatives, you will soon notice that even though you try very hard to use the correct exposure value, the negatives will often not have the same density or the same contrast. There is a relationship between the exposure value, the development, and the final image you see on the negative. The measurement of this relationship is called sensitometry.

SENSITOMETRY

Sensitometry deals with the sensitivity of film and photographic papers and thus relates closely to the ASA of a film. Because of sensitometry, we can learn to expect certain images to form on film based on certain exposures and developing procedures. The first people to deal with this were Hurter and Drifield, who in 1890 published their studies of how light affects film. This led to the time and temperature method of development that was used in Phase Eleven to develop your film. Their studies were plotted on a graph that became known as the H and D curve and showed that silver deposits increased as the exposure was increased. Today, their curve is known as the characteristic curve.

A characteristic curve plots the amount of exposure along the base of the graph and the density of the negative on the vertical scale of the graph. Density may be defined as the ability of the negative to transmit light. Density in a negative covers a range from clear or nearly clear areas that transmit much light, to nearly opaque areas that transmit little, if any light. This difference between high and low densities is often referred to as the contrast of the negative.

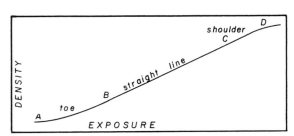

The characteristic curve.

119

The characteristic curve shown is not based on any particular film, exposure, or development. It is a sample curve to show the exposure-density relationship.

Exposure increases on the bottom scale from left to right, while density increases on the left scale from bottom to top. You will note that at point A the exposure has little effect on the density, but at point B the density increases at about the same rate as the exposure. At point C exposure no longer has as much influence on density. If exposure were to continue, the film density would reach a maximum (black when developed) and further increases in exposure would have no effect.

What does all this have to do with your negatives? Really quite a lot. Areas of the subject that reflect little light will create few silver deposits on the film and will be registered somewhere between A and B. Areas of the subject with medium brightness will be registered along the straight line. Finally, areas showing highlights will be very dense and will register on the shoulder between C and D. Areas completely white would go beyond D. A normal negative should have registrations all the way from the toe to the beginning of the shoulder. If the exposure gets too far into the shoulder, the negative becomes too dense and you lose the highlight areas; they will print completely white with no detail. If you get too far into the toe of the curve, you will not have sufficient exposure to record any detail. It is generally best to use the minimum exposure necessary to produce some detail in the shadow areas. This will keep the exposure from going too far into the shoulder—consequently blocking up highlight areas.

The following photographs illustrate how the characteristic curve may be applied to individual photographs for an understanding of sensitometry.

Left: Overexposure is evident in this photograph of a German parade. Shadow areas have registered near the toe of the curve with enough exposure to give good detail. However, the highlight areas—the hats, lace bibs, and buildings in the background—are too far into the shoulder of the curve. The negative is too dense in those areas to register detail. Right: This photograph of the Czar's bell in the Kremlin illustrates a correctly exposed negative. The screen over the broken section of the bell was registered in the toe of the curve with just enough exposure to record the detail. The various gray areas—the bell itself and the building in the background—are registered on the straight line. The shoulder is represented by the white shirts, which show some detail.

CONTRAST

We have previously defined contrast as the difference in densities found in any one negative. We say that a negative is contrasty if there is a great difference between densities.

Much contrast.

Little contrast.

The characteristic curve also plots the contrast of film. The steeper the straight line after the toe of the curve, the higher the film's contrast. Compare the curve for Plus-X with the curve for Kodak High Contrast Copy film.

Right: Characteristic curve for Plus -X film. Far right: Characteristic curve for High Contrast Copy film.

Contrast is not only a characteristic built into the film, it is also a result of the kind of developer used, the temperature of the developer, the time of development, and the amount of agitation. The increase in the contrast of Plus-X may be seen if

122

just one of these factors is changed. The chart below shows the effect of increasing the time of development on contrast.

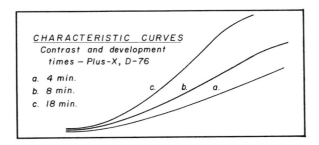

Increasing development time increases contrast.

These prints were made from negatives developed for the indicated times. D-76 diluted 1:1 was used at 68 degrees F. Note the increase in contrast with the increase in development time.

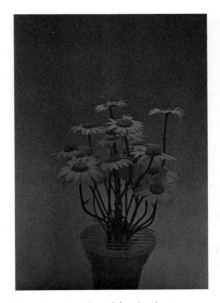 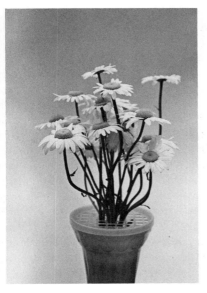 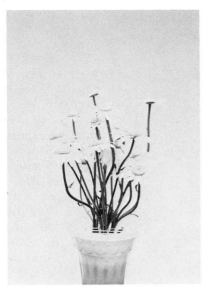

Negative developed for 4 minutes. *Negative developed for 8 minutes.* *Negative developed for 18 minutes.*

While all of the negatives were printable, the 18-min. print shows the most contrast, the least detail, and lacks the overall sparkle of a quality print. Good prints have a wide range of contrast obtainable only from a not-too-dense negative.

The other factors of temperature, developer choice, and agitation can all have equal influence on negative contrast. This is the reason that a consistent development procedure is so very important in achieving uniform results. It is not difficult to get results in black-and-white photography, but to get prints of the highest quality requires an understanding of the relationship of exposure and developing procedures. That is what sensitometry is all about. A knowledge of it will make you a better photographer.

EXPOSURE CONTROL SYSTEMS

Exposure is the basic beginning point of contrast in the negative. We have seen how exposure can affect shadow and highlight areas. The importance of exposure to final print quality has led some photographers to develop very precise systems for the determination of exposure.

One of the most highly developed of these systems is the Zone System used by Ansel Adams, a well-known photographer and writer. The system is based on a range of 10 shades of gray from Zone 0, which is black in the final print, to Zone 9, which is white. The zones are equal to a one-stop increase as you move from 1 to 2, from 2 to 3, and so on. Zone 5 is a medium gray and represents an average tone in a subject. Your reflection exposure meter is calibrated to reproduce this shade whether the scene is all black, all white, or a middle shade of gray. Most scenes have a light reflectance of 12 to 18 percent. For this reason, an 18 percent reflectance gray card (obtainable from photographic dealers) is sometimes held in front of the subject and the reading taken from it. Zone 5 is equivalent to the 18 percent gray card.

Of course, an average scene is not reproduced in only one shade of gray. But the meter starting point is Zone 5 so that other areas of reflectance in a scene may be reproduced in lighter or darker shades of gray. This will allow detail in Zones 3 through 7.

The Zone System allows this range of shades to be moved up or down the scale to accommodate areas of the scene that are outside the normal 3 to 7 scale. Should there be desired detail in a highlight area, Zone 8 or 9, it is possible to decrease the exposure by one stop, shifting all the other zones up the scale. This may possibly omit detail in the shadow areas of Zones 1 and 2. Or you may want to increase exposure to record the shadow detail in Zones 1 and 2. Conversely, this may block up detail in Zones 8 and 9 as the exposure shifts the zones down the scale. The important factor becomes the ability of the photographer to see the scene in terms of the Zone System. He can then determine the correct placement of the exposure on the scale in order to show the range of tones he desires in the final print. With this system, more of the zones are utilized to render various shades and fewer are lost in deep blacks and whites with no detail.

Increase exposure—greater detail in shadows.

Decrease exposure—greater detail in highlights.

The gray scale of the Zone System.

This photograph locates some of the shades of the gray scale. Most photographers try to render as many of these shades as possible in a single print, but much work in creative photography may use only a few of the shades (see Phase 17).

USING THE GRAY CARD AND THE ZONE SYSTEM

It is important to remember when using any zone system that when you meter a specific area in a scene, that area will be rendered the same as an 18 percent gray card, or Zone 5 in Adams' Zone System. In the first photograph on page 126, the girl's face was metered as Zone 5, too dark for normal representation of the average Caucasian face. A desirable result would be one stop lighter than the gray card or Zone 6. Opening the aperture one stop moves the scale down and provides a lighter shade.

125

Left: Direct meter reading renders the face too dark. Right: Opening the aperture one stop gives a better rendition.

If you wish the area to appear darker than Zone 5, the aperture must be closed down. Match the shade of the area to the Zone System to determine the number of stops adjustment needed. In the photograph of the logs, below left, a metering of the shadow area renders too light a print when no adjustments are made. Closing down three stops to Zone 2 makes it much darker, below right, but makes it match the shade of the scene more closely.

Direct meter reading of shadow renders shadow at 18 percent reflectance.

Closing down three stops gives better rendition.

PUSH PROCESSING

You may find circumstances, especially under dim light conditions, where you do not have enough light to make a proper exposure. Push processing is a way to compensate for this. The ASA of the film is doubled or tripled in order that you may use faster shutter settings or smaller apertures or simply a setting at full aperture opening and the slowest possible speed that can still be hand-held and still obtain a negative image. This kind of exposure value will be a long way from a zone-system exposure, but it may be the best possible under certain lighting conditions.

Since the film receives less light, an adjustment must be made in the development time. Usually a doubling of the ASA will mean a 50 percent increase of development time. A tripling of the ASA will necessitate an adjustment in both development time and temperature. When tripling ASA, it is possible to use high-energy developers, such as Acufine, which are specially made for this purpose. When using these, process according to the package directions.

Whenever film is pushed, some sacrifice is made in print quality. Pushing film will increase density and contrast and will make grain more noticeable.

The Tri-X film used for this photo was exposed at ASA 800 and developed in D-76 at 68 degrees F. for 12 minutes rather than the usual 8 minutes. Notice increase in contrast and graininess.

127

NEGATIVE INTENSIFICATION

If for some reason your negatives are very thin, that is they contain few deposits of silver, they may be intensified. This process of making the negative more opaque is not standard procedure; it should be used only as a last effort to save a negative you cannot retake. Special chromium intensifiers are available through photo stores. When using intensifiers, be sure to follow the instructions carefully.

NEGATIVE REDUCTION

If a negative is too dense it may be reduced to make it less opaque. There are various kinds of reducers on the market; all will make heavy negatives a bit easier to print. They should be used, though, only as a final effort to save a negative you cannot retake. Again, follow the manufacturer's directions.

RETICULATION

In rare instances, you may find that your negatives have taken on a texture similar to a very harsh grain. This is a result of changing solution temperatures, usually from a warm solution to a very cold solution, and is called reticulation. Sometimes it gives an artistic effect and is done on purpose. If you want to make a new piece of pottery look old in a photograph, reticulate the negative. To avoid the effect, use a temperature of 68 degrees F. for all solutions, including the wash water.

Reticulation can be used artistically.

A. Insufficient solution.

INSUFFICIENT SOLUTION

Insufficient solution in the developing tank can cause the negative to fully develop only to the solution line. Be certain that the film reel is completely covered with developer. See A above.

B. Exhausted solution.

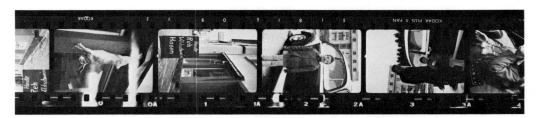

C. White areas.

EXHAUSTED SOLUTION

If a negative has areas of brown stains, it may be that the fixer was exhausted or that the film was not agitated in the fix. These discolorations will be evident when printing and will show on the final print. Refix the negatives in new hypo with proper agitation. See B above.

WHITE AREAS

White areas on the film are caused by two parts of the film touching and not allowing the developer to react properly on the emulsion. Take care in loading the reel to make certain two rotations of film are not in the same spiral. See C above.

OBJECTIVES — PHASE TWELVE

1. To define sensitometry, density, and contrast.
2. To interpret negatives against the characteristic curve.
3. To learn how to produce a photograph with the eight shades of gray of the Zone System and to identify these shades.
4. To determine exposure for a particular area of a scene using the 18 percent gray card and the Zone System.

FOR FURTHER REFERENCE

See *Camera and Lens: The Creative Approach* by Ansel Adams (Morgan and Morgan) for more on the Zone System as developed by Adams.

THE PRINT
PART FOUR

PHASE 13

THE DARKROOM

As you work with photography, you will soon desire to have a place other than a closet or the bathroom to do serious enlarging. A photographic darkroom need not be large; a room five feet square is sufficient. However, if you are going to spend considerable time in the room, with various types of equipment, you will need more room than that.

It is wise to plan your work areas so that one side of the room is reserved for the equipment needed for the exposure of papers and the other side for the processing of papers and films. If the wet processes are mixed with the dry processes, much of your work will be subject to the dangers of contamination. It is unpleasant to work for an hour on an 11″ × 14″ print only to discover that the paper was placed in a chemical accidently spilled from a developing or fixing tray.

The accompanying diagram suggests a possible darkroom layout with the enlarging, or dry, processes on one side and the developing, or wet, processes on the other. Note that there is a logical order to the layout. One starts with the enlarging process and works around the room.

Water—rinse

2nd fixing bath

1st fixing bath

Stop bath

Developer

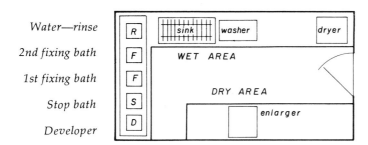

A well-ordered darkroom will make work easier, and there will be less chance of error.

THE ENLARGER

The basic piece of equipment required in the darkroom is the enlarger. It is simply a machine, much like a camera in reverse, that projects the small negative onto a large piece of enlarging paper. There are three principal types of enlargers:

Diffusion enlarger—This type consists of a light source that is projected through opal glass, through the negative and lens, and onto the paper. The diffusion enlarger tends to make rather flat prints.

133

Condenser enlarger—This type substitutes two condensers for the opal glass. These condensers collect the light and project it through the negative and lens onto the enlarging paper. The condenser type tends to make contrasty prints.

Combination diffusion/condenser—This is a compromise between the flat-printing diffusion enlarger and the contrasty-printing condenser enlarger. It employs a set of condensers to collect the light but also employs a ground glass to soften the light.

The principal concern in choosing an enlarger is the negative size you will be enlarging. While many of the bigger enlargers will accept smaller negative sizes, the reverse is not true. You should be certain of the film sizes you will be using and make your purchase on that basis.

The various parts that make up an enlarger are shown in the drawing on the following page. The principal parts are:

Baseboard—It supports the rest of the unit and provides a place to put the easel, which holds the enlarging paper.

Support column—This is attached to the baseboard and holds the enlarger head.

Enlarger head—Provides a place for the lamp, the condensers, the negative carriers, and the lens.

Negative carrier—Holds the negative. It may be an open frame or two pieces of glass between which the negative is sandwiched.

Lens—Forms an enlarged image on the baseboard. This is the heart of the enlarger and should be chosen with care. It is illogical to use an expensive camera lens and a cheap enlarging lens. The focal length of the enlarging lens should be chosen according to negative size. A rule of thumb is that the focal length of the lens should be the same as the normal focal length of the lens on your camera. That is, 35mm negatives will normally require a 50mm lens, since a 50mm lens is the normal lens on 35mm cameras. A 2¼″ × 2¼″ negative will take a 75mm lens as most 2¼″ × 2¼″ twin-lens reflex cameras have a normal lens close to 75mm.

Focusing control—This allows the lens to be moved up and down in relation to the negative in order to focus the negative sharply on the baseboard.

OTHER DARKROOM SUPPLIES

The list of supplies that may be used in the darkroom is almost endless, and one can easily spend a fortune on them. In reality, only a few basic items and chemicals are needed.

The safelight—The safelight is a low-wattage light source with a filter. Photographic paper can be exposed to a safelight for short periods of time. This gives the worker a minimum amount of light to work under. Most safelights use a 15-watt bulb and should be no closer than 4 feet from sensitive papers. Some of the newer

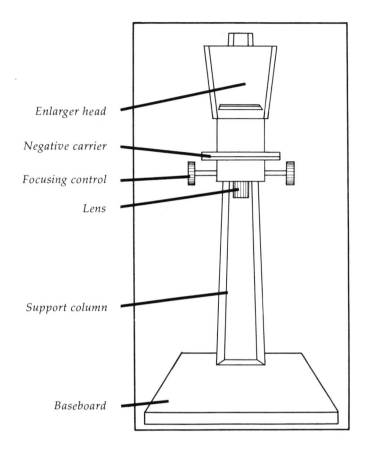

Enlarger head

Negative carrier

Focusing control

Lens

Support column

Baseboard

sodium-vapor safelights provide much brighter working conditions and yet are relatively safe—but they are expensive. The term safelight should not be interpreted to mean that the light will not fog papers. Any paper left out for prolonged periods will fog, or turn a shade of gray. Normal photographic enlarging papers require an OA filter (orange). Use a red filter for orthochromatic films.

Enlarging easel—This is a hinged device used to hold the paper flat on the baseboard of the enlarger. Some hold the paper in such a way as to make a white border around the picture area. Others produce borderless prints. Some adjust for various paper sizes, while others are made for only one size or a combination of specific sizes.

Photographic timer—A 60-second clock into which the enlarger is plugged. It allows the repeating of specific printing times.

Print trays—These are made of plastic or stainless steel in various sizes to hold the needed chemicals. Buy them a size larger than the print size you will normally be making to give room for print agitation.

Print tongs—These are used to agitate prints in the solutions and to move the prints from one solution to another.

135

Graduate—A glass or plastic cup with graduated markings for the proper mixing of chemicals.

Contact printer—This is not a necessity. It is a box with a light source and a glass plate on which a negative and contact paper are placed (emulsion to emulsion) and exposed. Prints produced are the same size as the negative. Much the same process was used to make pinhole positives—a contact positive was made from the paper negative by contact printing the two together. Paper used in a contact printer is much slower than regular enlarging paper.

Developer—Does much the same thing as a film developer. A common product is Kodak Dektol. It is used from a stock solution with two parts of water.

Stop bath—The same acetic acid solution used for film. This is also available in an "indicating" solution that turns dark when the acid is exhausted.

Fixer—The solution used for films may normally be used for papers. Some fixing solutions have a hardener built in and others have none. If you plan to tone your prints, you should use a fixer without a hardener.

PHOTOGRAPHIC PAPERS

There are so many enlarging papers on the market that choice becomes somewhat complicated. The following items could be considered in choosing papers:

Size—The popular sizes are 4″ × 5″, 5″ × 7″, 8″ × 10″, 11″ × 14″, and 16″ × 20″.

Weight—Papers are sold in single- or double-weight thickness. Larger size papers are normally double weight to avoid tearing in handling. Paper in the 8″ × 10″ size is usually available in both single and double weights.

Inexpensive safelight.

Easel with four print sizes (one on reverse side).

Timer.

Trays, tongs, and graduate.

137

Speed—Some papers are more sensitive than others and thus take a shorter time to expose. Papers that are too slow tend to take such a long exposure that the negative may buckle from the heat of the enlarging lamp. Papers that are too fast will not allow for dodging and burning-in techniques. Most papers can be properly exposed in 5 to 30 seconds although this is modified by the degree of magnification, the speed of the enlarging lens, the density of the negative, and the power of the enlarging lamp.

Tone—Papers may be neutral in tone, cold tone, or warm tone. Cold papers produce bluish tones, while warm-tone papers have a brownish cast. Warm-tone papers are often used for portraits, while cold-tone papers are often used for journalistic work as they give richer blacks.

Surface—There is a great range of surfaces available from the glossy, smooth surface, which produces very rich blacks and fine detail, to the very rough, textured surface with a pebbled finish that can hide detail. Glossy papers are generally used for prints that are to be reproduced. Other surfaces are often used for prints that are to be shown and for portraits. A textured surface can hide many faults, but it does not have the printing range that a glossy paper has. While both tone and surface are a matter of choice and personal preference, there is a certain logic that should be used in relation to subject matter and eventual use of the print. Resin-coated papers provide shorter fixing and washing times; however, they are not available in many textures.

Contrast—Most enlarging papers are available in several contrast grades. The contrast of a paper is a measure of its ability to register the extremes of contrast in the negative. If the negative is very contrasty, it is an indication that a paper grade

A soft negative printed on soft (No. 1) paper.

A soft negative printed on hard (No. 4) paper.

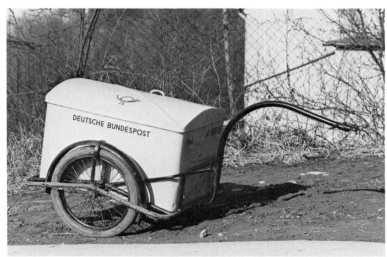

A hard negative printed on soft (No. 1) paper.

The same negative printed on hard (No 4.) paper gives very contrasty results.

of 0 or 1 should be used. If a negative has little contrast, a paper grade of 4, 5, or even 6 should be considered. A grade of 2 is usually normal, but since paper manufacturers are not consistent in grading, a No. 2 from one company may be like a No. 1 or 3 of another company. Sometimes the terms hard and soft are applied to papers and negatives. A soft paper is not as contrasty as a hard paper. A soft negative lacks contrast, while a hard negative is very contrasty. Generally, a soft negative is printed on hard paper and a hard negative is printed on soft paper to achieve the best results. Some photographers intentionally mismatch paper grade and negative contrast to get special effects.

Enlarging papers are also made in variable-contrast grades. This allows the use of a single paper for all negative contrasts. A series of filters is needed to produce the various contrasts. The use of variable-contrast paper gives greater control over the degree of contrast desired in the final print.

OBJECTIVES — PHASE THIRTEEN

1. To plan a darkroom layout that allows convenient utilization of equipment and materials.
2. To learn how to choose an enlarger wisely.
3. To learn how to equip a darkroom with the minimum supplies needed.
4. To choose photographic paper according to certain characteristics.
5. To learn how to match paper grade and negative contrast properly.

FOR FURTHER REFERENCE

See *Lootens on Photographic Enlarging and Print Quality* by J. Ghislain Lootens (Amphoto) for more information on enlargers and papers.

See *The Print* by the editors of Time-Life for a discussion of the basic parts of the enlarger and more on papers.

PRINTING

We have finally arrived at the most enjoyable experience that photography affords. Printing or enlarging is the end result of those many hours of learning and utilizing the camera controls and exposing and developing the negative. The benefits of working carefully will be evident in the final print. Continued care and proper procedure are as important now as ever if results of professional quality are to be obtained.

CONTACT PRINTING NEGATIVES

The quickest way to get an idea of what your negatives look like is to contact print them onto a large sheet of enlarging paper. This is a simple process that may be done with an 8″ × 10″ piece of glass and an enlarger.

Start with a strip of 35mm negatives and cut a piece of enlarging paper the same size as the negative strip. Choose a strip of negatives that are consistent in density. Place the negatives, emulsion side down, on top of the emulsion side of the enlarging paper. Put both on the baseboard of the enlarger and cover with the glass. Avoid cutting yourself by putting a strip of masking tape around the edges of the glass. It is good practice to set the enlarger aperture at $f/8$ or $f/11$. This will normally give you maximum sharpness. Set the timer for 5 seconds. Cover all but one fourth of the strip with a piece of cardboard and start the timer. After 5 seconds, move the cardboard so that one half the strip is covered. Expose and move the cardboard again so that only one fourth of the paper is covered. Expose and finally remove the cardboard completely, exposing for the final 5 seconds. When developed, your positive strip will have four areas ranging from light to dark corresponding to the exposure times given.

Now you can choose the best exposure time. The test on page 142 shows that an exposure of about 8 seconds gives the best print, as 5 seconds is a bit light and 10 seconds a bit dark. Next, place all the negatives on one large 8″ × 10″ sheet of paper, cover with the glass to hold them in place, expose for 8 seconds, and process.

A proof printer will make contact printing a bit easier, but consider it a luxury unless you do a great amount of contact printing from your negatives. Proof sheets are very handy if stored along with the negatives. They allow you to find wanted negatives in a hurry. Because of their small size, contact images tell you little about 35mm negative quality unless they are examined with a magnifying glass.

141

A proof printer.

PAPER PROCESSING

When processing enlarging papers, try to keep the processing solutions at a temperature of 68 degrees F. After the paper is exposed, insert it into the developer and agitate it by moving one corner of the tray up and down. Keep the solution moving to assure even development. The photograph should develop in one to two minutes. Do not pull the paper out if it looks like it is too dark. If the paper appears too dark, the exposure time must be decreased. The darkness of the print must be controlled under the enlarger and not in the developing solution. While it is possible to leave a print in the developer more than two minutes, this can lead to fogged prints. If paper is left in the developer for less than two minutes, streaks and a mottled appearance may result.

When using tongs to remove the print from solution, take great care not to scratch the emulsion side of the print. After development, remove the print from the developer and allow it to drain about 15 seconds. Place in the stop bath—this is an acetic acid solution, made by mixing 6 ounces of 28 percent acetic acid with a gallon of water. To avoid spattering the acid when mixing, always add acid to water, not water to acid. You may want to use an indicating stop bath in place of the standard solution. The indicating stop bath will turn a very dark color when it is exhausted. With either solution, keep the print face up in it and agitate for 15 seconds.

Developed for 30 seconds. Note mottled appearance.

Developed for two minutes. Note rich blacks.

Now drain the print for 15 seconds and place it in the fixing bath. The fixing bath is important, for it is here that any unexposed silver halide particles are dissolved. Since there is a possibility of a bleaching action occurring if a print is left too long in the fixing bath, it becomes very important to fix prints the correct amount of time. While the directions on the particular fixer you are using should be followed, most fixers do their work in from 5 to 10 minutes. The solution must be agitated and the prints must not be allowed to accumulate in the bath. It is a good idea to periodically turn the prints over one by one if you have more than one in the bath at the same time. Most fixing baths have a capacity of about a hundred 8″ × 10″ prints per gallon. Do not exceed this unless you use the two-bath system. In this system, you first start with two fresh baths of fixer. Fix the prints in each bath for 3 to 5 minutes. The first bath may be used for the equivalent of about two hundred 8″ × 10″ prints and then discarded. Now substitute the second bath for the first one and mix a new second bath. Don't forget to agitate the prints in both baths.

Washing is the final step, and if done properly, you will be assured of prints that will not stain and fade. To reduce washing time, use a hypo eliminator before you place the prints in the wash water. Follow the directions on the brand you are using. Prints treated in this solution will wash cleaner of hypo and silver than is possible when the hypo eliminator step is omitted, and colder water can be used. It is good practice to wash prints for at least 30 minutes if hypo eliminator has been used, and for one hour if not. There must be a constant flow of fresh water over the prints. Prints that just soak in a pan of water will not be free of hypo and silver. Washing time can be reduced with resin-coated papers.

Above: Inexpensive tray syphon for washing prints. Below: Large-capacity drum-type print washer.

Washing is a very important step in the photographic process, yet many seem to overlook its importance. A large amount of money is spent on cameras, but few people buy the necessary equipment to assure prints that will be permanent. If not too many prints are washed at any one time, an inexpensive faucet attachment may be used with a deep tray. The drum-type washer will do a good job with large quantities of prints, but it is much more expensive.

After washing, it is necessary to properly dry the prints so that they will be as flat as possible. If you are using a matte-finish paper, you may insert the wet prints between sheets of blotter paper made especially for this purpose. This blotter paper is also available in rolls. Simply remove excess water from the print by wiping it with a soft, damp sponge or by squeegeeing with a rubber squeegee. Place the prints face down on the blotter paper. If you use an electric print dryer for matte prints, place their faces against the canvas. Do not use an extremely high temperature and do not overdry them. Prints that are subjected to high heat will not lie flat, their edges will buckle, and they will be difficult to mount for display purposes.

Prints that need to dry with a glossy finish can be ferrotyped on a plate made for that purpose. These are polished plates of chrome-plated brass or steel. It is necessary to squeegee the wet print onto the ferrotype plate with a rubber roller. Work from the inside of the print toward the edges to remove any air bubbles. Air bubbles will cause "unglazed" spots. Be certain that the print is completely dry before trying to remove it from the tin. Should the print contain unglazed spots when removed from the tin, it may be resoaked and redried.

The resin-coated papers will produce a high gloss without ferrotyping. These papers greatly simplify the procedures for making glossy prints.

Drying a print between blotter sheets.

Drying a matte printe on an electric dryer.

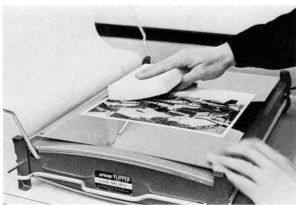

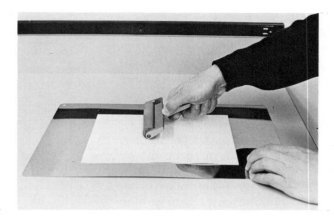
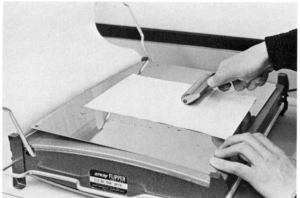

Ferrotyping for air drying.

Using the electric dryer with ferrotype plate.

GENERAL PRINTING

The procedure for making enlargements will follow the pattern covered previously for making contact sheets. The one major exception is the location of the negative. For enlargements the negative is inserted in the negative carrier. Naturally, the size of the negative carrier must match the negative size. Be certain the negative is clean and free of dust and lint. Place it with the emulsion side toward the baseboard of the enlarger. The negative may now be projected on the easel for size adjustment and focusing.

If you start with a normal negative, that is, one of normal contrast, you should use a normal contrast grade of paper (No. 2). Develop the habit of making a test strip for all of your work until you can accurately estimate the correct exposure times required. Place the test strip over the area where the center of interest in the photograph is projected. Remember to set the aperture at *f*/8 after focusing at full aperture, and make a series of exposures at 5 seconds each. If all of the exposures are too dark, then cut this time in half. It is a good idea to fix the test strip and take it under normal room lighting for examination. Prints normally appear too dark under the safelight of the darkroom; you will be surprised how much lighter they appear under normal lighting. If you are making a big enlargement, it is not wasteful to make a full-size test. Examine this under normal lighting for proper exposure and for any spots caused by dust or lint. Try to correct all the faults before making the final print.

In examining the test strip for proper exposure, look at the highlights. The highlights should contain some texture and detail. If the highlight is a face, it should not appear ghost-like. If it does, either the exposure was too short or the paper too high in contrast. Choose a softer paper or give a longer exposure. The same is true of shadow areas. If they are completely blocked up and no detail is evident, you may need to choose a paper with more contrast or decrease exposure. Remember that you have chosen a normal negative—one that exhibits detail in both the highlights and the shadow areas. A negative that is very hard (contrasty) will not print shadow detail no matter what paper grade you choose. With a normal negative, though, you should be able to produce a print with a wide range of gray tones and with detail in both shadow and highlight areas.

Study the test strip carefully before making the final print.

Use of a test strip, and careful examination of it, will result in a good quality print. This photograph of Neuschwanstein castle in Bavaria exhibits a good range of grays from white to black. A normal negative and normal paper grade will produce results like this.

Use of a test strip and careful examination of it will result in a good quality print. This photograph of Neuschwanstein castle in Bavaria exhibits a good range of grays from white to black. A normal negative and normal paper grade will produce results like this.

147

OBJECTIVES — PHASE FOURTEEN

1. To learn the use of a test strip to determine correct exposure times.
2. To learn contact printing.
3. To know the steps to process paper correctly for permanence.
4. To learn how to make a test strip for an enlargement.
5. To know how to produce an enlargement.

FOR FURTHER REFERENCE

See *The Print* by the editors of Time-Life for more on contact printing a series of negatives.

See Kodak booklet G-5, *Professional Printing in Black and White,* for more on processing black-and-white papers.

See *Lootens on Photographic Enlarging and Print Quality* by J. Ghislain Lootens (Amphoto) for details related to this phase.

Check Satow's *35mm NEGS and PRINTS* (Amphoto) for additional material related to processing.

Careful printing can result in much personal satisfaction.

PRINT CORRECTION

It is not always possible to obtain a correctly exposed negative no matter how carefully you work. Much can be done in the darkroom to correct a negative that will not give a satisfactory print with normal printing. This phase will cover some of the methods of print correction.

PRINT APPRAISAL

The easiest way to appraise a print is to make one on the grade of paper you feel is correct and with the exposure you feel is correct based on a test strip. Then after processing, examine it under normal room lights to determine any correction needed. Corrective procedures you may want to use are:

cropping
dodging
burning
flashing
vignetting
reducing
perspective correction
spotting

CROPPING

Utilizing only part of the negative in the enlarging process is called cropping. It is a method of bringing out the center of interest more effectively and/or eliminating unwanted areas of the negative. To crop, simply move the enlarging easel on the baseboard to obtain the section of the negative you wish to use. At times, you may want to mask the negative in the enlarger to eliminate unwanted areas. This will lessen the possibility of stray light bouncing onto the paper from various bright objects in the room, such as an enlarger column.

149

Above: While this photograph has a center of interest, there are too many distractions around the edges. Below: Cropping produces a more satisfactory photograph. The eye can concentrate on the center of interest.

DODGING

Dodging is an easy method of keeping an area of the print from becoming too dark from too much exposure. It is especially useful for keeping shadow areas from going black and losing detail. Dodging can be done with the hand or with small pieces of cardboard attached to a long wire. Using a piece of cardboard on a wire allows an inside area of the print to be held back without an arm or hand holding back other areas also. Hold the dodging tool fairly close to the lens of the enlarger and keep it moving so that even tones will result. The time needed will depend on a number of factors and will be determined by trial and error and experience.

Dodging tools.

Using a dodging tool.

Left: In this photograph, the faces are too dark, yet the rest of the print is quite acceptable. Right: Dodging improves the faces without changing the darkness of the remainder of the print.

BURNING

Related to dodging is the corrective method of burning, sometimes called printing-in. Burning is the increase of exposure on certain selected areas of the print. The technique is often used to darken skies. (When you expose certain sections for a longer period of time, you are at the same time holding back, or dodging, the remainder of the print.) Burning is also used to darken the edges of a print to move the eye toward the center of interest. Like dodging, you must keep your hand moving so that there is a gradual change from the lighter areas to the darker areas.

The paving blocks in this photograph of Red Square are too light, yet the Kremlin wall and the people waiting on line are correctly exposed.

By holding back the upper section of the print and burning-in the street, an acceptable print is made.

Print without darkened edges.

Burning-in the edges of the print moves the eye toward the center of interest.

153

Photograph without flashing.

Flashing improves the print.

FLASHING

Flashing is a method of darkening areas of a print without building up contrast. In burning, the light was projected through the negative onto the paper; areas that were burned still retained contrast. Flashing is done with no negative in the enlarger so that all areas receive the same additional exposure. In this way, distracting elements can be blended into the background without increasing contrast between highlight and shadow areas. Sometimes flashing is done with an external light source, such as a small 7-watt light bulb partly covered with tape to cut the amount of light. If an external bulb is used, the negative can remain in the enlarger, the red filter can be put in place, and the enlarger light turned on to give the exact location of the needed flashing. A flashlight with a cloth over the lens is good for flashing specific areas of a print.

VIGNETTING

Vignetting is a holding-back process used in portrait work to eliminate background and make the viewer concentrate on a subject's face. A vignetter may be made by cutting a ragged hole in a piece of cardboard. Vignetters may also be purchased from your local photo dealer. When in use, keep the vignetter moving so that a gradual tonal change is made from the subject to the white background.

Left: Using the vignetter. Below left: Before vignetting. Below right: Vignetting eliminates a distracting background.

REDUCTION

Reduction is a chemical process that can be used to alter the print density for a better tonal range. Farmer's Reducer is most often used. Consult the product instructions for the correct mixing procedures. A print may be reduced before it is dried, or resoaked in water and treated in the reducer if it has already been dried. After reduction, the print should be rinsed and refixed in plain hypo, not an acid or hardener hypo. Wash completely before drying.

Left: Before reduction. Right: Tonal quality improves with reduction.

SPOTTING

Regardless of the care you take in cleaning negatives, some of your prints are going to have small white spots from lint and dust. It is possible to hide these spots with a very small brush and a commercial product made for this purpose. Spotone is a product available in a variety of tones. To use it, first dip the brush in water and then touch it to a blotter to absorb most of the water. Then dip the brush in the spotting liquid. Do the spots in the darkest areas first, working toward the lighter areas as the material wears from the brush. Keep a fine point on the brush and use a stippling motion. Do not paint the material onto the print. Hold the brush in an almost vertical position and touch the point to the print surface. You will find matte prints the easiest to spot and glossy ones the hardest.

Using spotting liquid to touch-up a print.

Uncorrected print shows a convergence of lines that should be parallel.

PERSPECTIVE CORRECTION

Unless you are fortunate enough to have a perspective control lens or a view camera, you have probably noticed that if you aim your camera up at a high building the building tends to lean away from you. This can be corrected in the darkroom by tilting the enlarging easel. The degree of tilt will depend on the amount of correction needed. Some burning-in will have to be done on the side furthest from the lens of the enlarger to compensate for the additional distance. The depth of field your enlarging lens gives will determine how much correction you will be able to make.

Tilting the enlarging easel can correct the linear convergence slightly.

159

TONING

Toners are used to convert the silver image on black-and-white prints into colored images. This process should not be thought of as a necessary corrective device, but rather as a possible way to enhance a photograph.

Toning is done after the print is thoroughly washed. Ferrotyped prints are very difficult to tone; however, you may ferrotype a print after it is toned. Toning actually removes some of the silver image, and thus the length of time the print remains in the toner should be limited to 4–10 minutes. Agitate occasionally during the toning process. Wash in water 10–20 minutes after toning.

Toners are usually available in red, brown, blue, yellow, and green. Choice of color will often depend on the subject, but interesting effects can be obtained by using colors beyond the normal subject color.

Black-and-white photographs may also be colored using photo oil colors such as Marshall's Photo-Oil Colors. This is a process of hand coloring non-glossy prints into full color photographs. It is a time consuming job, but it can result in some very beautiful prints. Photo oils will allow the use of many colors on one print, while toners limit you to only one color on a print.

OBJECTIVES — PHASE FIFTEEN

1. To learn how to appraise a print for correction.
2. To understand how to crop a print for better composition.
3. To understand dodging and burning.
4. To learn how to flash a print to eliminate distraction.
5. To learn how to vignette a portrait.
6. To know how to reduce a print for better tonal value.
7. To learn how to correct perspective at the enlarger.
8. To know how to properly spot a print.
9. To understand toning and hand coloring.

FOR FURTHER REFERENCE

Lootens on Photographic Enlarging and Print Quality (Amphoto) is the best reference for this phase.

See also *The Print* by the editors of Time-Life.

VISUALIZATION
PART FIVE

SEEING AND CAMERA TECHNIQUE

The production of a perfect picture by means of photography is an art;
the production of a technically perfect negative is a science.

*Journal of the Society of
Chemical Industry*—1890

It was realized long ago that the making of a good photograph took more than technical skill.

Seeing is an important part of photography and seeing is difficult. To make consistently good photographs requires careful seeing. This is not to devalue the record shots that are taken all the time by all types of photographers, or an occasional successful accident. Those pictures have value, but their value is usually limited to the photographer or his immediate family. To them the pictures have meaning, much of it hidden to anyone else.

Seeing is difficult because you must perceive how a particular photograph will be accepted by the general public. While it is good to get away from the age-old cliches of composition and other accepted standards of photography, there are still generalities that help make a photograph "say something." Among these are such things as depth or perspective, detail, point of view, size and scale, texture and form, and placement. These are all parts which together form a whole. Not all of them are used in every photograph, but the parts that are used should work together. It is this total effect that speaks to all who see. It may not have the same meaning to everyone, because different people have had different experiences—but an effective photo will speak to some.

One of the most important parts forming this whole is placement. Placement is called composition by some. Composition, in a sense, is the organizing of all of the parts into an effective communicative piece. Basically, it is the placing of items in relation to one another that creates a composition. We shall be concerned with this placement, along with the other factors that make an effective photograph, in this phase.

THE CLASSIC PATTERNS OF COMPOSITION

The following illustrations show six classic patterns of composition. You may or may not choose to utilize them in your photographs.

The rule of thirds divides the scene into thirds both horizontally and vertically. The lines intersect at pleasing positions for subject placement. This avoids

163

The rule of thirds.

Repetition (rhythm).

The "S" curve.

Oval or circular.

164

The "L."

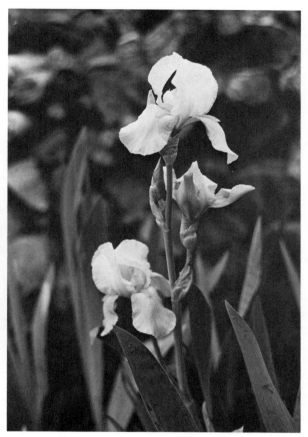

The triangle.

placing the center of interest in the center of the picture where it becomes static.

Repetition of lines or objects is a popular form of composition, especially when patterns form the dominant subject. Horizontal lines usually express harmony and depth, while vertical lines limit depth and act as barriers in the photograph.

Oval or circular lines give a sense of beauty and grace. The eye moves around the circle, pausing in a leisurely fashion. Ovals and circles are peaceful.

The "S" curve is another form of beauty and grace. It is one of the best known forms of composition. The eye is led along the gentle curve to the major center of interest. Be certain there is a center of interest on that curve.

Another well-known form of composition is the "L." The objects on the base of the "L" provide stability for the vertical portion.

The triangle has long been used as a basis of composition. Its three points make a more dynamic composition than if two or four points were used to bring an image together.

165

POINT OF VIEW

Most cameras used today are used at eye level, and they produce pictures that appear normal to us. By varying the viewpoint, new and unusual results can be obtained. Probably the high viewpoint is more often used than the low, but in both cases it is possible to remove distracting elements from the background and thus focus more attention on the subject.

Above: A high camera position provides a new and different view of the Palace of Fine Arts in Mexico City. Above opposite: A low viewpoint makes the observer concentrate on one subject from a low angle. Right: The viewpoint of the photographer as well as camera aim can combine to make photographs more dynamic, especially if the horizon is kept above or below the horizontal center line of the photo. This will also help give a spatial effect to the sky if a low horizon is used, and to the land if a high horizon is used.

166

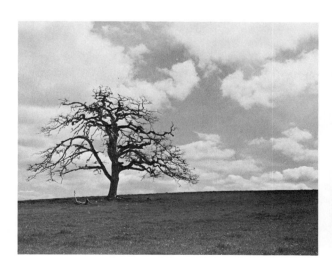

Above left: This photograph of mountains of the Olympic Peninsula illustrates the illusion of depth. Above right: The longer the focal length, the greater the compression effect. Below: Wide-angle lenses appear to spread things out. They give a feeling of space and freedom.

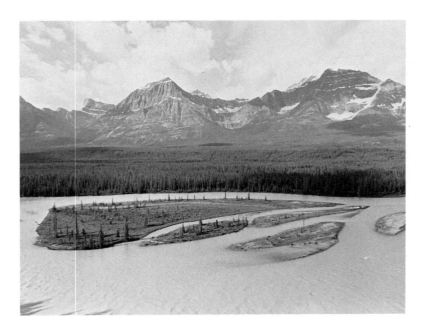

PERSPECTIVE (DEPTH)

The illusion of depth in a photograph is often based on a change in tonal values as distance increases. Subjects further away appear lighter than nearer subjects. This is shown in the photograph, far left, with the dark nearby meadow and the much lighter distant mountains of the Olympic Peninsula.

Long lenses can compress depth and make objects look closer together than they really are. Wide-angle lenses appear to spread things out and give a feeling of freedom. Lens choice can have great impact on final results, and therefore on what you are trying to say. Experience will allow you to see the effect of a certain lens before you take the picture.

IMAGE SIZE AND SCALE

Choice of focal length will also determine image size. The photo showing the full glacier was taken with a 35mm lens. The inclusion of people gives some indication of scale in relation to the size of the glacier. The other photo, taken with a 270mm lens (135mm lens with a 2× extender), shows only a small portion of Alaska's Mendenhall glacier. Note the difficulty in interpreting scale.

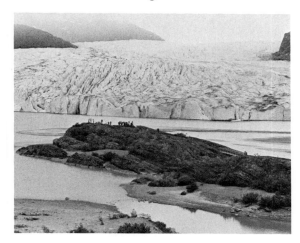

Taken with a 35mm lens.

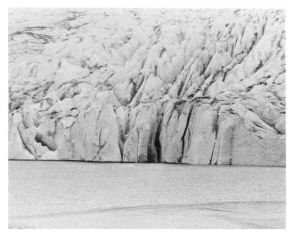

Taken with a 270mm lens (135mm lens with 2× extender).

TEXTURE

Texture can also give a feeling of a third dimension in a photograph. Depth is shown by placement of sidelighting to create shadow and highlight. With certain subjects it also provides a tactile sense in addition to a third dimension.

Right: Tree bark with strong sidelighting. Below: Apples and burlap.

170

FORM

Attention to highlight and shadow through careful positioning of lighting gives a three-dimensional object form with depth.

Air Force jet fighters.

TIME

In a photograph, time is much harder to show than scale, space, or depth. However, there are a number of ways to show time in a still picture. One way is to lead the eye from one point to another. This in itself indicates time. Another way is to show movement through blur. Even the body position of a subject may indicate movement, without any need for blur. A basketball player frozen in a jump shot will project movement. Care must be taken to compose your photos with space in front of the subject in which it can "move."

Broken filament.

Tulips.

MOVING IN CLOSE

Most of what we see is filled with distractions. Our mind must continually sort out what is significant from the mass of things before us. Moving in close is a simple way to help the viewer see what you felt to be important. It is an easy way to eliminate the distractions and concentrate on the center of interest. Photography provides the medium to see far more detail than is possible by glancing at a real situation—don't hesitate to move in close. A telephoto lens or a set of extension rings can help.

OBJECTIVES —PHASE SIXTEEN

1. To learn to see with a camera by applying the classic patterns of composition.
2. To learn to see with a camera by using point of view to improve composition.
3. To show depth, image size, scale, time, texture, and form in photographs.
4. To isolate the center of interest by moving in close.

FOR FURTHER REFERENCE

See G. Insert's book *The Art of Color Photography* (Van Nostrand) for a great section on composition.

The Art of Photography by the editors of Time-Life gives information on the principles of design in photography.

For an excellent collection of photographs for studying various techniques used throughout the history of photography, see Peter Pollack's book *The Picture History of Photography* (Abrams).

See also Andreas Feininger's *Principles of Composition in Photography* (Amphoto).

CREATIVE PROCESSES

PART SIX

GETTING AWAY FROM IT ALL

One of the most fascinating aspects of photography is in the area of darkroom creativity. By utilizing various films and papers, along with other-than-ordinary darkroom procedures, a whole new world of imagery is available. This phase will deal with this new world of creative processes.

PHOTOGRAMS

The simplest creative process that takes us beyond the usual continuous photograph is the photogram. No camera is needed in this process; the complete photograph is made in the darkroom. One does not even need an enlarger. The only required materials are enlarging papers and processing chemicals for that paper.

To make a photogram, simply lay the subject—bolts, screws, nuts, thread, leaves, or whatever—on the printing paper and expose to light. The objects form a white silhouette on the printing paper. This may be reversed by contact printing as discussed in Phase Two. The result will be a black silhouette on a white background.

Continued experimentation will result in some very interesting results. Try to keep the photogram simple and always concentrate on the essentials of design covered in the previous phase. Try, especially, to avoid the placing of the objects in the physical center of the photogram. Lead the eye from the outer edges of the photogram to the center of interest. Try working with exposures of different lengths; expose some materials for several seconds and remove them, leaving other objects on the paper for a longer time. This will result in some areas being black, some gray, and others white. Objects printed gray will become subordinate to ones printed in stark black or white. The center of interest can be more easily emphasized in this way.

The accompanying photograms will give some idea of what is possible. You can take it from here.

175

Above left: Negative photogram. Above right: Positive photogram. Below left: Printing for various times. Below right: Positive contact of photogram made by varying exposure.

176

HIGH CONTRAST

High-contrast techniques eliminate the intermediate tones of the continuous-tone negative with the resultant print having only blacks and whites. This is done by contact printing the regular continuous-tone negative onto high-contrast graphic arts film—Kodalith Ortho, Type 3, works well for this purpose. It is available in 35mm in 100-foot rolls and in 4″ × 5″ and larger sheets. It is an orthochromatic film, so it can be used under red safelights in the darkroom. Kodalith is a slow film having an ASA of about 4, and is thus easy to handle in the darkroom.

To expose a high-contrast film, such as Kodalith, one can either contact print the negative or place the continuous-tone negative in the negative carrier and project it onto the graphic arts film. The latter results in an enlarged positive, while the former results in a positive the same size as the negative.

The high-contrast film should be developed in its own special developer. Kodalith has a two part developer. Parts A and B should not be mixed together until the time of use as the tray life of the mixed chemicals is very short. Kodalith film can be developed in Dektol, but the results will be continuous tone.

To obtain a negative from the high-contrast positive, simply contact print the positive onto another sheet of high-contrast film. From this negative you may print the positive photograph in the normal manner. You may find that sometimes a print from the positive is more effective for a particular subject. Either way you will find the use of graphic arts high-contrast film exciting.

Normal, continuous-tone negative. *Normal, continuous-tone positive.*

 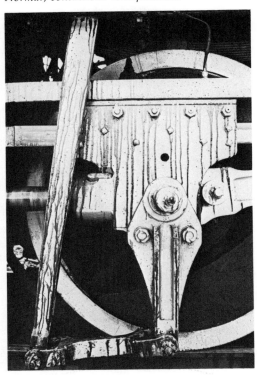

Right: High-contrast negative. Far right: High-contrast positive. Below: High-contrast graphic arts film offers an interesting departure from the ordinary continuous-tone photograph.

178

POSTERIZATION

The use of high-contrast film as indicated on the previous pages is really a form of posterization. Pictures produced by separating tones have a poster-like quality, and thus the term posterization is used to describe them. Taking the procedure one step further, we can make a four-tone posterized print in the following manner:

1. Using a continuous-tone negative, expose high-contrast film for a long enough time to produce an overexposed positive showing only highlights with all other areas blocked up.
2. With the same continuous-tone negative, produce a high-contrast positive that is underexposed, giving adequate exposure on only the thinnest part of the negative.
3. Now do the same only giving a normal exposure between the two other extremes. You now have three high-contrast positives with different tones from the same continuous-tone negative.
4. Contact print one high-contrast negative of each positive using the same exposure time for each to retain the difference in the tones of each positive.
5. You are now ready to make the final print on enlarging paper from the three high-contrast negatives. These high-contrast negatives, or tone separations, must be printed in exact registration. If you are working with very large negatives, a register printing frame should be used to keep the negatives in perfect register. For smaller negatives, you can simply put them in the same corner of the printing easel to obtain registration.

Print the darkest negative first, using an exposure which gives a light gray, then the middle-tone negative, and finally the lightest negative. Use the same exposure for each of the negatives. Now process the print. The shadow areas, having received all three exposures, will be black; the middle tones, with two exposures, will be dark gray; the highlights, with one exposure, will be light gray; and the complete highlights will be white since they received no exposure.

Overexposed separation. *Normal separation.* *Underexposed separation.*

This four-tone posterization was produced from three high-contrast negatives, each having a different tone separation.

LINE CONVERSION

A further extension of high-contrast work is the sandwiching of both positive and negative high-contrast films together. If these are slightly out of register, a line negative will result. A more definite line can be obtained by placing the positive and negative in exact register (film base to film base) on top of a new sheet of high-contrast film and placing the whole package on a turntable. Expose the film with an oblique light so that the light rays penetrate through the small space between the layers of emulsion. The thickness of the film base and the angle of the light will both influence the thickness of the resultant lines. Thicker film bases will produce broader lines, as will light angles nearer 45 degrees than 90 degrees.

High-contrast negative.

High-contrast positive.

Line conversion.

SOLARIZATION

Solarization is a process that exposes film or enlarging paper to white light *during development.* Technically, the term solarization refers to the reversal of image tones in the early printing-out processes (see Phase Seven, The Latent Image: A History). The process is also called the Sabattier Effect, named after Armand Sabattier who gave it to us in 1862.

In the solarization process, we develop a print without agitation in the developer. Small piles of bromide are formed between the dense and light areas of the print. Now we expose the print to white light for a very brief time. The light areas of the print will become dark upon further development, and the piles of bromide will appear as white lines, giving us a line-drawing effect on a background of surrealistic tones.

Solarization will produce a type of line effect with interesting tonal variations.

TEXTURE SCREENS

Commercially produced texture screens can be used to add regular texture patterns to your photographs. However, you may make your own screens by photographing textured glass, concrete surfaces, wood grains, and other surfaces. It is preferable that these negatives, or positives, be the same size as the final print you'll make. They seem to lose their effectiveness if they are enlarged along with the negative when making the final print. Large-size screens may be easily made by enlarging a 35mm high-contrast negative onto an 8″ × 10″ sheet of Kodalith. This large sheet can then be easily contact printed after the regular negative is printed.

The use of texture screens is part of the creative process and experimentation is desirable. Try using them with continuous-tone negatives as well as high-contrast negatives.

Screen and negative printed separately.

Negative printed first, removed from the enlarger, and then the screen contact-printed.

COMBINATIONS

Combination printing is simply using more than one negative to produce a complete photograph. In its simplest form, it is the combining of two continuous-tone negatives to form one photograph. A typical example of combination printing is the addition of clouds to a bare sky. The addition of seagulls to a seascape is another. Our use of texture screens was still another.

Creative combination printing, more often, is the result of the combining of photograms, texture screens, line drawings, and high-contrast negatives.

Combination printing may require the use of opaquing materials to eliminate unwanted details. This material is painted on the negative to eliminate small pinholes or other unwanted or distracting elements from the negative.

How far you go with combination printing is up to you. A search of magazine advertisements will give you many ideas once you are familiar with the techniques discussed in this phase.

The addition of seagulls to a seascape is a typical example of combination printing.

MULTIPLE-IMAGE CAMERAS

And now we have gone full circle; we are back to the simple camera. It is possible to do creative things with simple cameras by adding additional apertures. The accompanying photo shows a simple camera with five apertures. An exposure is made either with all apertures open to one subject, or by making individual exposures of different subjects. Either printing paper or high-contrast film may be used. High-contrast film in 4″ × 5″ size works well using the same box that it comes in for the camera housing. This camera costs only about 15 cents, yet it can provide many hours of enjoyment. To determine relative aperture and focal length, and thus exposure, refer back to Phase Two.

The multiple-image simple camera.

The original negative for this photo was made on high-contrast film and then enlarged to the size shown. The center aperture was exposed to the grill of a car and the four outer apertures to a wheel.

185

OBJECTIVES—PHASE SEVENTEEN

1. To show how to make a photogram.
2. To learn how to use high-contrast film to produce both positive and negative prints.
3. To learn how to use high-contrast film to produce tone separations for posterization.
4. To understand the making of line conversions using sandwiched high-contrast positives and negatives.
5. To know how to solarize a print.
6. To learn how to utilize texture screens.
7. To understand the making of creative combinations using the above processes plus continuous-tone negatives.
8. To learn how to build and use a multiple-image camera.

FOR FURTHER REFERENCE

See *Making Photograms: The Creative Process of Painting With Light* by Virna Haffer (Amphoto) for an excellent study of this process.

Two other books wholly devoted to creative processes are O. R. Croy's *Design by Photography* and *Darkroom Magic* by Otto Litzel (Amphoto). Both are quite good, showing the process step by step.

Frontiers of Photography by the editors of Time-Life has a short section of some of the processes presented in this phase.

Check also Paul Petzold's *Effects and Experiments in Photography* (Amphoto).

Solarization by Rainwater and Walker (Amphoto) provides an interesting new slant on the subject.

DISPLAY TECHNIQUES

When you have worked hard to produce a really creative photograph, you have earned the right to display it. Display techniques are not at all difficult. After spotting is completed, should it be necessary, there are really only two decisions to make: Should the photograph be mounted? If mounted, should it have a border or be bled out to the edges of the mount?

DRY MOUNTING

Simple print mounts are commercially available. The print is first taped at the corners of the mount, and then the surrounding border is dropped down over the print. This type of mount is often used for portraits and is easy to use.

Another method of mounting actually bonds the photo to the mounting board. Most photographers use a thermo mounting tissue that is placed between the print and the mounting board. Heat from a household iron or from a mounting press is used to attach the picture to the mount. There are two types of mounting tissue, a permanent tissue and one that can be removed with the reapplication of heat. The non-permanent tissue requires a lower heat level for mounting and is thus probably preferable for photographs.

If the photo and the mounting board are the same size, the first step is to cut the tissue. It is a good idea to cut it about $1/16$ in. smaller than the actual photograph. With a tacking iron or a household iron set on low, tack two opposite corners of the tissue to the back of the photograph. Now place the photograph on the mounting board and tack the other two corners by lifting the corners of the photograph. Do not place the iron directly on the print. Whether you use a mounting press or an iron, be certain to place the mounting board with the photograph between two large sheets of kraft paper. Place the whole unit in the press for less than a minute at the recommended temperature.

When using the non-permanent tissue, it is necessary to place weights on the photograph after removal from the press. This material adheres upon cooling. If the iron is used for heat, run it back and forth over the kraft paper and then cover the mounted print with weights.

Tacking the tissue to the print.

Tacking the print to the board.

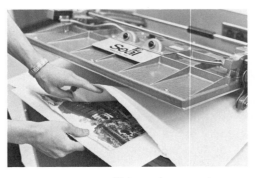

Using a dry-mount press.

Placing the print under weights.

FLUSH MOUNTING AND BORDERS

It is your artistic decision as to whether to use a border or to flush mount the photograph out to the edges of the mounting board. A print can be given an entirely different look by this choice.

If you do use borders, the print appearance can be further changed by the choice of borders. Consider the two accompanying photos of the same rock. An entirely different effect is obtained when the black mount is used instead of the white mount.

Applying an underlay of art paper and then attaching this to the mounting board is another way to make a creative mount.

Thin tapes may dress up a print. Stationery and art stores have these in various widths and colors. You may also make borders with India ink. Another method of mounting uses a second piece of mounting board for a frame. This places the print behind a cut-out opening and gives the mounted photograph a feeling of depth.

A matted print has a feeling of depth.

OBJECTIVES — PHASE EIGHTEEN

1. To learn how to mount photographs using dry-mount tissue.
2. To understand the use of underlays, line borders, and matte-mounting techniques to dress up prints for display.

FOR FURTHER REFERENCE

See *Photography* by Phil Davis (William C. Brown Co.) for more on print finishing.

INDEX